e-flux journal

Elizabeth A. Povinelli
Routes/Worlds

Sternberg Press

Contents

Foreword
5

Preface
11

What Do White People Want? Interest, Desire, and Affect in Late Liberalism
15

Routes/Worlds
25

After the Last Man: Images and Ethics of Becoming Otherwise
48

Horizons and Frontiers, Late Liberal Territoriality, and Toxic Habitats
66

Time/Bank, Effort/Embankments
82

In the Event of Precarity … A Conversation with Lauren Berlant
91

After a Screening of *When the Dogs Talked* at Columbia University with Audra Simpson and Liza Johnson
108

The Urban Intensions of Geontopower
122

Mother Earth: Public Sphere, Biosphere, Colonial Sphere
143

The Ancestral Present of Oceanic Illusions: Connected and Differentiated in Late Toxic Liberalism
164

Shapes of Freedom: A Conversation with Kim Turcot DiFruscia
191

The Virus: Figure and Infrastructure
209

Foreword

The first time we worked with Elizabeth Povinelli was on an essay for a special issue of *e-flux journal* on alternative economies. At the time, we thought we were dealing with a professor of anthropology, which was not wrong—Povinelli was, and still is, the Franz Boas Professor of Anthropology at Columbia University. And her 2011 essay "Routes/Worlds" had plenty of insights from the field of anthropology.

Early in the development of *e-flux journal*, the primary idea was to publish writing by artists. As editors, we had observed that many artists were fabulous thinkers and scholars in their own right. Their work gave the written form lots of imaginative twists and anxious self-questioning, which were often missing from theory and other academic writing. Artists, we thought, were less pious in their thinking and delivery, less bounded in their scholarship. Elizabeth Povinelli flipped the script on us profoundly.

As we continued to read and publish her work, it became increasingly clear that Povinelli was not only a scholar but, perhaps more than anything, an artist. From the films of Karrabing—an extended family in Australia of which she is a part—to her psychedelic drawings of elaborate pipelines penetrating geological and ideological strata, Povinelli has consistently worked to create and share a unique place from which to think and work. This place is not an idyllic refuge but a vantage point from which to map alternate pathways for visualizing where the failures of enormous ideological and historical systems rub up against their promises. Povinelli's writing, film, and illustration work all explore these systems, often at different intensities and scales.

"Routes/Worlds" also opened a line of inquiry that Povinelli would continue to pursue in further

essays and books. Through ongoing writing in the journal and elsewhere, she mapped the creation and dismantling of worlds formed by the twinning of historical progress and settler colonialism—as a unity in events and a contradiction in ideology. Even if corporations and nation-states now collude in the same Ponzi schemes, they still continue to transform space and time. At the receiving end of the ideological exhaust pipe, where transformation is inherited as deformation, the diagram flips to place brutality and existential exhaustion at the beginning. But the beginning of what? Please, not the beginning of another return to the original promise that nations and corporations will make all of us safe and wealthy. How about a new beginning, starting with modes of survival and persistence against, and within, a world built from deferred promises? This is a world that many in the imperial hemisphere are only starting to realize they've known for longer than they want to admit.

"Routes/Worlds" was the first in a three-part exploration on time, effort, and endurance in late liberalism (followed by "After the Last Man: Images and Ethics of Becoming Otherwise" and "Time/Bank, Effort/Embankments," all in this book) that culminated in our "Quasi-Events" special issue, which Povinelli guest-edited in October 2014. The issue explored a counter-form to the teleological historical time that was thought to arrive at universal democracy through a series of questions on how to fully inhabit the promise that never arrives, and the half project that never resolves as a fully formed political event. Against this late liberal backdrop of disappointment, amid the rotting body of planetary social progress and the pneumatic suction of planetary capitalism, how do we understand the immanent politics of the "pure simultaneity of

yes/no"? In the 2016 essay that opens this book, "What Do White People Want? Interest, Desire, and Affect in Late Liberalism," Povinelli identifies this politics in the Trump and Brexit constituents who voted yes in order to vote no.

A fourth essay might have been appended to the trilogy when Povinelli wrote "Horizons and Frontiers, Late Liberal Territoriality, and Toxic Habitats" for another special issue in April 2018, which arose from Vivian Ziherl's "Toxic Assets" conference at e-flux in New York. Developed in close conversation with Povinelli and her thinking on late liberalism, the conference identified the frontier as a crucial convergence of ideology and topology that structures colonial desire. We had actually sought out Vivian in 2012 after she cannily plonked a line from the "Routes/Worlds" essay into a Facebook post responding to the swelling number of biennial exhibitions around the globe:

> The surround is without an opening. It is an infinity of homogeneous space and time. It is an "everywhere at the same time" and a "nowhere else." One can go here or there in the surround, but it really makes no difference because there are no meaningful distinctions left to orient oneself toward—to determine where one goes or what one believes or holds true.

Here, the living conditions and orientation of life within an ideology that refuses to be one reflects how Povinelli's territorial morphology also understands "late liberalism" as a triumph of colonial expansion that has to simultaneously manage the misery of colonial extraction.

Taken together, Povinelli's writing might be read in terms of its remarkable perseverance in

rearticulating large-scale systems of power and affect, even as—or precisely because—those systems stage increasingly novel forms of neglect. Our experiential life-worlds may want to close in on themselves or burrow into the safety of local soil already ravaged by distant toxicities—from centuries ago or from a factory on the other side of the planet—or into notions of identity that were constructed by those very same systems of transtemporal traffic. Access to these large scales was never granted only by way of faster airlines or satellite maps, but actually through the historical mechanisms that constructed us, whether as selves or as communities. Today, it only becomes clearer that struggles to survive day-to-day challenges are most often struggles against sedimented raw deals whose disastrous logic needs to be traced over large expanses of space and time to become perceptible. In this constant struggle, a friend like Elizabeth— we call her Beth—provides weapons as well as inspiration.

Julieta Aranda, Kaye Cain-Nielsen, Brian Kuan Wood, and Anton Vidokle

Preface

This collection began in a class I taught at Columbia University in 2006. Julieta Aranda was doing her MFA in the School of the Arts there, and petitioned to attend a class I was teaching on translation, transfiguration, and circulation. It was from thinking with her that I began what has become a joyously open and explorative relationship with *e-flux journal* and its other editors Anton Vidokle and Brian Kuan Wood.

This collection is dedicated to these three transformative colleagues.

Routes/Worlds includes most of the essays I have published in *e-flux journal* over a ten-year period, from 2011 to 2021. Fittingly, the title of this volume is taken from the first essay I wrote for the journal. The essays span a significant period in my thinking; indeed, they are the formative first outlines of what in some instances have become book-length monographs, and in other instances films and artworks. "The Virus: Figure and Infrastructure" tells a story about my thinking across this very period, as I moved into *Economies of Abandonment* on the way to *Between Gaia and Ground*. Other thoughts expressed in these essays have occasioned new sustaining friendships and collaborations. All were written with the spirit of the journal; a spirit that is at once and the same time critically focused, narratively exploratory, and, perhaps, overly polemic. I have always felt *e-flux journal* to be a space where I can experiment with my thought; I hope it has marked my writing and work elsewhere.

A major thematic that emerges across these essays is the dead dialectic of liberal capitalism and the persistence of decolonizing practices. Alongside others, I have been attempting to do two simultaneous things. On the one hand, to probe the discourses

and tactics that allow liberalism and capitalism to skirt the ongoing violence of their continual movements across the earth. This is the explicit theme of "Horizons and Frontiers" and "After the Last Man," but it also animates "The Urban Intensions of Geontopower." Some might read this work as ideology critique, and I have no reason not to embrace such a description, especially if we do not conflate ideology and the unconscious. The essays are also, however, attempting to think history as the material sedimentation of late liberal discourses and tactics of justification and legitimation. Thus, in "The Urban Intensions of Geontopower," I urge us to ponder the place of the colonial as we watch W. E. B. Du Bois walking the paved streets of Brussels and visiting the arcades that Walter Benjamin saw as the archetypical space of the modern flaneur. Ditto with "Routes/Worlds": How do we understand ideological or late liberal imaginaries as material infrastructures that violently rearrange material relations, leaving toxic residues in their wake? How do we begin with the sedimentations of ideology and the ideologies of sedimentation, whether we are discussing oceans, Anthropocenes, freedoms, or desires? Moreover, how do we rematerialize mental life as an effort of time and embankment? With whatever language we choose, how do we make a space between the ways in which dominant forms of power shape and reshape material and mental life?

The essays are also marked by the beginning of the Karrabing Film Collective and what I have been calling the Heritability Project. Meaning "low tide" in the Emmiyengal language, "karrabing" refers to a form of collectivity outside of government-imposed strictures of clanship or land ownership. We were just completing our first film project, *When the Dogs Talked*, when I published "Routes/Worlds,"

and I was just beginning to draw what would become *The Inheritance*. At stake in the essay is the dynamic of what I called "the figurating function of routes." Using cargo capitalism as an example—cargo ships, air passenger planes, and data cargo, such as the Karrabing GIS/GPS-based augmented reality project, as well as human cargo, such as my Povinelli clan's descent from their Alpine village into the United States at the turn of the nineteenth century—I tried to show how power works by determining the material shapes and social meanings of what moves through late liberal infrastructures and how stubborn persistence of the otherwise and residual toxicities of the infrastructures themselves continually deform power. *When the Dogs Talked* and subsequent Karrabing films have probed the settler colonial infrastructures in which their ancestral present stubbornly remains. "What Do White People Want?," written in the wake of the Trump presidential victory, probes the stubborn refusal of militant and laissez-faire whiteness to relinquish the infrastructures that circuit social and material values toward them and deposit their toxic residues elsewhere.

I am not sure what the next ten years might bring any of us, but I hope I will look back over another decade of intellectual engagement with the e-flux community.

>Elizabeth A. Povinelli
>New York City, June 6, 2021

What Do White People Want? Interest, Desire, and Affect in Late Liberalism

Although I was asked to speak on the topic of affect, my remarks might be better framed with the question "what do white people want?" Many people have already remarked on the percentage of white men who voted for Trump. But we must also acknowledge the number of suburban and rural women who didn't care about pussies or cocks—who didn't care about harassment by Trump or by the exiled Roger Ailes. And we know that some nonwhite Americans also voted for Trump, no matter the blunt racist discourse of the president-elect and those around him. But the reason for asking these questions is not to cite the theoretical misogyny of Freudian psychoanalysis but to open a conversation about the current formations of race and gender in the vicinity of global late liberal interest, desire, and affect.

The relationship between interest and desire was the question that riveted left political theory in the wake of the emergence of Thatcherism and Reaganism in the 1980s. In the context of the US the question was simply put: Why did the white working class vote against its own interest? Scholars sought to understand how Reagan's assault on African American communities (the "welfare queen") and on unions via the spectacle of air traffic controllers was crucial to his capture of the white middle and working class vote and a culmination of a long-standing "southern strategy,"[1] and how the supposed end of the nation-state was merely a strategy for the advancement of capital rather than a break in history.[2] Although articulating a very different social history, we thought we saw a similar dynamic in Thatcher's ability to turn the white working class against itself in the infamous miners' strike and whites against Black Britain.[3] It was in this context that Gayatri Spivak famously penned "Can the Subaltern Speak?," in which she

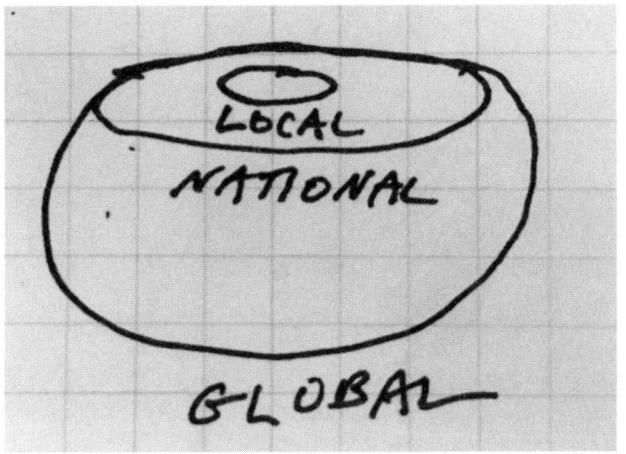

Drawing 1

Drawing 2

differentiated between interest and desire—capital as the international division of labor and desire as identification and subjectification. This prehistory of interest and desire is, I think, important to remember if we are to understand Trump not through the framework of American exceptionalism but rather, as with Reagan and Thatcher, within a topological transformation of liberalism itself. If we are to understand Trump, perhaps the first thing we need to do is pull our American heads out of the exceptionalist ass of America. Just as biopolitics did not begin in Europe—and not the biopolitics of *The Birth of Biopolitics*, but the biopolitical of the last chapters of *Society Must Be Defended*—but rather in the vicious excesses of the African colonies,[4] so Trump's prefiguration is not merely the Italian despots of Mussolini and Berlusconi but the Bataillean corporeal spectacle of the African postcolonial leader.

Instead of all is the same, all is different, Trump's election provides us an opportunity to return to these questions as a means of changing our understanding not merely of the current topology of interest and the question of desire, but also of the problem of affect in relation to both. What is interest now? What is the relation between desire and interest and desire and language, not merely in the context of the impossibility of identity at their intersection but in the context of what we are told is a new post-truth era in which William Burroughs's man who taught his asshole to talk has taken office? How might separating the problem of affect from the problem of desire help us make our way through this fecal moment?

First, what is the topography of interest and desire today? How do we know that the so-called deplorables voted against their interests if we don't know what the structure of interest is? Perhaps the

deplorables voted in their interest from one frame of reference, but in organizing their desire from within another unleashed a torrent of hate such that the entire separation undergoes a conflagration. In other words, what topology of late liberalism organized the rage and revolt of the deplorables? And how does it relate to the imaginary topologies in which we have been sunk? These remarks are merely remarks, so let me telegraph the point perhaps all too quickly. Since the 1980s, the imaginary of the "-scapes"[5] and of globalization have displaced the imaginary of nations and their states. Indeed, the 1990s witnessed endless announcements about the end of the local and the nation-state and the twilight of the Westphalian model. The global, glocal, translocal, and transglocal were just some of the terms and neologisms created to capture the aftereffects of transnational neoliberal capital.[6] Sometimes a scalar model is used to represent this new formation of interest (Drawing 1); sometimes a model of circulation is used (Drawing 2).

And yet, the arrival of Trump, the Brexit vote, the surge of the Right throughout Europe and its embrace of Putinism, and other disturbances within the classic axis of liberalism demand, I believe, a slightly different topological model, one that better reflects the deplorables' analysis of late liberalism (Drawing 3). Here we see two forms of relationality that are neither exactly different nor exactly the same as the two previous. The nation-state remains as a place for and the source of an extraction of capital for those for whom the nation-state is an irrelevant or counter-form of identity. Their mode of sociality and accumulation operates via the movement through, but without the same identificatory or economic constraints of, the nation-state as those outside the circuits. Indeed, perhaps the

best ways of conceiving these circuits of identity, accumulation, and circulation—circuits that are simultaneously dependent on and independent of the nation-state—are tubular, or better, pneumonic. They are forms of suction in which extraction and flight are part of the same process. It is exactly this structure that many Trump and Brexit voters point to when justifying their vote. They present a choice to the urban, liberal, post-national population and the financially elite circulating within these pneumatic tubes—if you are a part of the nation-state on which a part of the condition of your life depends, then you must abide by the same conditions of those of us outside. The vote might be seen, in effect, as an attempt to seal these tubes. And in this sense the analytics behind the vote are not wrong.

Of course, the dynamics of desire, organized according to special regional histories and discourses, hardly align with this analytics of interest. The white populism of US nationalism makes "the wages of whiteness" a crucial element of the imaginary of pneumatic capitalism.[7] It is not a distortion so much as a desire to maintain a dominant relationship between economic benefit and race. Thus the pneumatics of late liberalism meets the ghetto of American race history—as white populism attempts to seal its privilege against two forms of expansion, the expansion of Black revolt as witnessed in the Black Lives Matter movement and the expansion of a diverse post-nationalist national citizenry at the upper and lower ends of the financial spectrum (low-wage-labor immigration and high-wage multiurbanism).

So why do we need "affect" when the concepts of interest and desire still appear to do a working man's job of analyzing the conditions of the present? Of course, the usefulness of the concept

depends on what we mean to indicate in its usage. Here I use affect to indicate desire not as it has been captured by the discourses of language and subjectivity but in the Spinozean sense (or the sense Deleuze gave to Spinoza), namely, a mode of thought that doesn't present anything. A will/volition/force that is not *for* something and that does not represent something else, but a pure revolt. This is not Freudian repression. Not lack. It is the pure simultaneity of yes/no. And here we can no longer ask "what do white people want?" and believe that there will be an answer that corresponds to interest or desire. Instead, Trump and Brexit voters vote yes in order to vote no. They vote yes in order to vote against the expansion of a form of existence whose viability depends on continually vacuuming ever more finite sources from the nation-state while claiming—or living as if—they had no interest in it. The global expansion of explosive affect is intensified by the simultaneous expansion of the individual via social media and the tight restriction of the same individual in terms of her imaginary socioeconomic future.

And here we reach a set of uncomfortable conclusions. This yes in order to differ makes analytic sense as it is fueled by and fuels a torrent of racism, misogyny, and anti-(the right kind of) immigrant and alt-right phobias of all sorts. It also helps us understand why the deplorables are not simply white, not simply white men, but a variety of social identities and relations, though not nearly as large a voting class as the first. And finally, it helps understand why this is not a US event, but rather part of a global roiling. There is nothing exceptional about Trump.

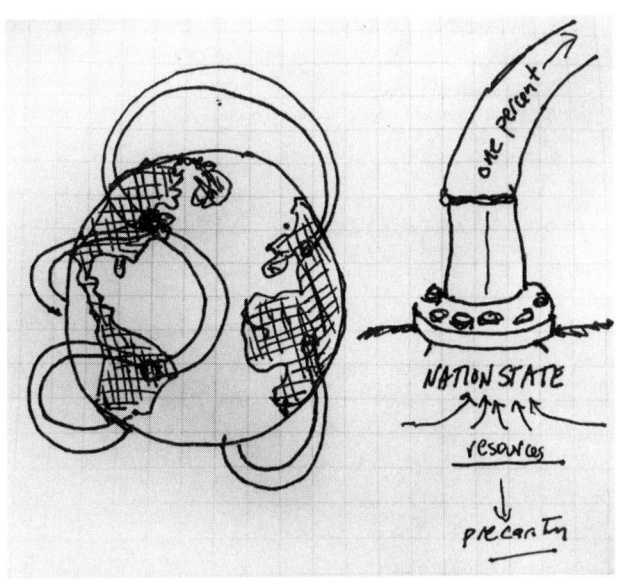

Drawing 3

All drawings by the author

1
David R. Roediger, *Working Toward Whiteness: How America's Immigrants Became White* (New York: Basic Books, 2005).

2
David Harvey, *Spaces of Global Capitalism: Towards a Theory of Uneven Geographical Development* (London: Verso, 2006).

3
Michelle Alexander, *The New Jim Crow: Mass Incarceration in the Age of Colorblindness* (New York: New Press, 2010).

4
Achille Mbembe, "Necropolitics," *Public Culture* 15, no. 1 (2003).

5
Arjun Appadurai, "Disjuncture and Difference in the Global Cultural Economy," *Public Culture* 2, no. 2 (1990).

6
Harvey, *Spaces of Global Capitalism*.

7
Roediger, *Working Toward Whiteness;* W. E. B. Du Bois, *Black Reconstruction in America, 1860–1880* (New York: Free Press, 1999); and Michael Kazin, *The Populist Persuasion: An American History*, rev. ed. (Ithaca, NY: Cornell University Press, 1995).

Routes/Worlds

For some time, I have been interested in developing an anthropology of the otherwise. This anthropology locates itself within forms of life that are at odds with dominant, and dominating, modes of being. One can often tell when or where one of these forms of life has emerged, because it typically produces an immunological response in the host mode of being. In other words, when a form of life emerges contrary to dominant modes of social being, the dominant mode experiences this form as inside and yet foreign to its body. For some, the dominant image of this mode of interior exteriority is the Möbius strip, for others the rhizome, and still others the parasite.[1] But what if the dominant visual metaphor of the anthropology of the otherwise were a woven bag?

How might one consider the anthropology of the otherwise through gift economies and alternative currencies and communities, and in turn consider emergent forms of social being in relation to what I am calling the *embagination* of space by the circulation of things? As I hope will become clear, conceptualizing social space as a kind of *embagination* foregrounds the fact that gift economies can close a world but never seal it. Every gift economy creates simultaneous surplus, excess, deficits, and abscesses in material and memory, and thus the most profound gift is given at the limit of community. Thus, in exchange for the invitation to participate in the publication you have before you, I offer a series of thoughts on how spheres of life emerge and collapse, and expand and deflate, as things move and are moved across space and time. I will begin with a discussion of the anthropology of the gift, turn to contemporary debates between Bruno Latour and Peter Sloterdijk about the relative values of network and sphere theory, and end

with reflections on two recent projects—a graphic memoir and an augmented reality venture—that elaborate what I mean by *embagination*.

The Gift

At the center of modern anthropological lore is a person who created a discipline by describing a practice wherein to give away was to receive more in return. The person was the Polish scholar Bronisław Malinowski, who chose to remain on the Trobriand Islands rather than spend the First World War in an Australian internment camp.[2] The practice was *Kula*. Malinowski claimed that, at its simplest, Kula was an intertribal exchange of ceremonial objects (red shell necklaces and white shell bracelets) that traveled in opposite directions in a closed circuit along established routes. No man—and for Malinowski it was always men, if not all men—knew where Kula objects traveled outside his local purview. And no man could keep the object he received nor, once in, could he opt out of this ritualized exchange.[3] "A partnership between two men is a permanent and lifelong affair."[4] The things that moved between them could also never stop moving. Once within the circle of Kula exchange, ritual objects only left when they physically perished.[5] But if the ceremonial exchange of necklaces and bracelets publicly defined Kula, "a greater number of secondary activities and features" took place "under its cover," including the ordinary trade and barter of various goods and utilities that, although indispensible for everyday life, were often locally unavailable.[6] As a result, Kula embraced an interconnected complex of activities, created an organic social whole out of disparate social parts, and established a hierarchy of prestige that defined this social world in part

and in whole.[7] Ceremonial necklaces and bracelets were given, accepted, and reciprocated, but what returned was not mere jewelry, but a world. This world was fabricated by the hierarchies of power and prestige Kula established, represented, and conserved; and by the ordinary activities that went on under its cover, embedding these hierarchies of prestige ever deeper into the fabric of everyday life.

If we are interested in how Kula provides a genealogical backdrop to network and sphere theory, let alone to new forms of exchange communities, then three observations about Malinowski's methodological and conceptual claims are pertinent. First, Malinowski sought to found the discipline of anthropology on the premise that the anthropologist had a different analytical perspective on the social world than "the native," namely, that the anthropologist could see the total social system of exchange whereas "the native" could only see his local part. Second, in order to produce this anthropological point of view, the anthropologist had to abstract the Trobrianders from the diachronic nature of Kula (that Kula lines were always being made and remade) and himself from the history that connected him to his subjects. And third, anthropologists had to reconceptualize acts of reciprocity as the condition rather than the end of sociality—reciprocity does not end social relations but knits them.

The understanding of "gift economies" as a vital part of the machinery of social power was essential to Marcel Mauss's reinterpretation of Malinowski's account of Kula and other ethnographies of the Pacific in *The Gift*. For Mauss, the gift had a straightforward tripartite structure—the obligation to give, to receive, and to reciprocate. It also had a dominant spirit. Gift giving was not an exercise in treaty making. It was an exercise of aggression

Edward S. Curtis, Tolowa Indian measuring shell money, 1923. Photo: Edward S. Curtis Collection (Library of Congress/Public Domain)

wrapped in dazzling ribbons and elaborate language. Although new networks are formed through seduction and wooing, the spirit of the gift was more akin to the gods of war than the gods of peace.[8] To offer a gift was to assert power (*mana*, *hau*) over another, a power that remained until the recipient could reverse the dynamic. In other words, if the offer of a gift was an invitation to sociality, it was also an announcement of the onset of a perpetual war of debt in which the books could never be settled. If the recipient of a gift was unable to reciprocate, then any *mana* he had accumulated in previous exchanges was nullified. Thus anyone who enters the Kula wages that he will acquire more prestige *in due time*, but he also risks losing all the prestige he has previously acquired—and more, since he might lose not only what he has gained but also, in coming to know what he might have had, he might lose his innocence as well. In short, Malinowski and Mauss read Kula as a kind of bank, and banking as a kind of warfare. Before banks, before currency, valuable things were placed in circulation as *lines* of credit whose ultimate end was to return to the sender having accumulated surplus value. Participants gave in order to increase their holdings, but this interested act created something more than the interested rational subject—it created moral obligations and social worlds.[9]

The great French anthropologist Claude Lévi-Strauss would take this insight and make it the foundation of the incest taboo and subsequently his structural anthropology. The incest taboo was not a prohibition against sex so much as a prohibition against hoarding. Men—and for Lévi-Strauss, like Mauss, this was a man's world—had an obligation to indebt others by giving them valuables—the most valuable of all values being a woman. To indebt a

person was not an antisocial act but the very conditions of sociality. Here Lévi-Strauss followed Marx, who also saw hoarding as an antisocial practice. For Marx, as for Lévi-Strauss, human sociality depended on a kind of reflexive fold that appears when one sends out a value in order for it to return having gained a surplus.[10] These reflexively structured routes make the worlds within which people dwell.

While Lévi-Strauss's views about men's manipulation of women, words, and goods have been subjected to a thorough critique, his representation of the world of human exchange offered us a new visual metaphor—a sealed bag.[11] Several qualities of this sealed bag bear noting. First, whereas Lévi-Strauss saw the social worlds that emerged in the circuit of credit and debt as a structurally closed totality, from a diachronic perspective new social networks were always being added or removed such that the symmetrical form of the matrix was always being distorted. In other words, a bag might appear sealed off from other surrounding bags from a synchronic point of view, but if we take into account Mauss's argument that new lines of gift exchange are always being created through seduction, then from a diachronic point of view, the strings that open and shut it reappear. Second, Lévi-Strauss gave volume to gift exchange. The famous signifying chain was revealed not to be a chain so much as a set of interlinked fences that enclose a world giving it semantic volume and weight as well as pragmatic space and time. It would seem, then, that Lévi-Strauss overcame a certain problem Sloterdijk would later diagnose as endemic to network theory (and here we could add to Malinowski's schematic representation of the gift). The problem with network theory, Sloterdijk claims, is that it overstates the linear connections of points within a planar

surface to the detriment of the intrinsic volume of all social space—network theory replicates rather than analyzes the Euclidean hierarchy in which a point is that which has no part, lines are made out of these empty points, planes from lines, and spheres from planes. For Sloterdijk—and it would seem for Lévi-Strauss as well—because humans cannot reside in a point, in the beginning there was the bubble.[12] Third, for Lévi-Strauss, because every cultural world feels like a closed space to those within it, each cultural world is structured immunologically, in the sense that each world interprets every difference within it as a possible foreign invasion and uses mechanisms to neutralize, expel, or extinguish this "invasion."

But whether they foreground a symmetrical (synchronic) or asymmetrical (diachronic) matrix, anthropologists of the gift saw the prohibition against hoarding valuables and the obligation to enter into debt/credit relations as vital to the creation of self-reflexive folds that make social and cultural worlds possible. If people were allowed to hoard their valuables, no social matrix could be fabricated out of the reflexive networks of giving and receiving. Social space would not bend back on itself and form pockets of communication and inhabitation. Instead, space would remain empty, negating any place for humans to dwell. We can think of these reflexive movements as a kind of *embagination* of space—the creation of a flexible receptacle closed in all places except where it can be tied and untied. But, again, this fold, or embagination, fabricates a world in which individuals, and competing worlds, attempt to dwell—to their advantage or disadvantage.

Routes/Worlds

It is in this light that the anthropology of the gift provides a genealogical backdrop to Latour's network theory and Sloterdjik's theory of spheres. To borrow from Latour, gift exchange can be seen as one kind of network: it creates nodes and linkages as things (whether men, women, boys, ritual bracelets, pigs, or words) circulate and are localized. And, insofar as gifts return, they create a specific kind of envelope—a self-reflexive sphere—in which a life-world might emerge. But this life-world relies not on points that have no part but on thick networks of differentiation where actual and potential meaningful inhabitation takes place.[13] Thus, for Malinowski, Kula stitched space together reflexively, creating enclosures that the Trobrianders experienced as *their* world. And Lévi-Strauss believed that the universal circulation of women in particular ways, and the indebtedness and risk this circulation created, stitched together particular cultural spaces. For Lévi-Strauss, women were the needles that men used to fabricate cultural spaces out of universal space, human enclosures out of abstract opens, each according to their particular pattern. But as feminist and queer scholars demonstrated the gendered nature of anthropological accounts of the gift, other needles came to emerge.[14]

Anthropology, even before the rise of structural anthropology, initially treated these human enclosures as if they had no drawstrings, ignoring the networks that allowed them to enter these embagged worlds in the first place (so Malinowski did not discuss the forms of circulation and governance that allowed him to choose between the Trobiand Islands and an Australian internment camp). But, following colonial, feminist, and

anti-colonial critiques, anthropologists became interested in the networks that ran between and into clusters of embagged worlds, and how these networks pulsed with various forms of debt, risk, and power, with various hierarchies of being and existence.[15] When the strings forming and connecting embagged space began dominating disciplinary interest, the anthropology of globalization and transnationalism emerged. And this is one of the great lessons that the anthropology of the gift—and later the anthropology of circulation—bestowed on us: that things do not simply move. Routes *figure* space—they create worlds—and are figured by figurated space, by the worlds through which they move.[16] They are the condition of previous circulatory matrixes and become part of the matrix that decides which other kinds of things can pass through and be made sense of within this figured space. And routes configure things—they shape them into 3D manifestations. What "things" are—what counts as an entity—should be understood broadly. Whether container ships, kin or stranger socialities, psychic expectations, affective intensities, linguistic forms: all form, conform, and deform existing cultures of circulation. Social institutions, or "demanding environments," emerge around these material and affective curvatures, effectively controlling the further fabrication of things and their movements.[17]

As an example of the dynamic between the figurating function of routes, we need look no further than the Panama Canal. Ashley Carse has examined how it was not only the landscapes around the Panama Canal that were reorganized by its creation and management, but the shipping that passed through it. To see what is at stake here we must first take seriously the materiality of the earth, and assume that moving goods across continents

through waterways is not an abstract idea, but a history of material fabrication. Various routes exist or have been built to allow ships to minimize transport costs and maximize profit. The Panama Canal became one of the key transit points for shipping when it was completed in 1914. Originally, all sizes and shapes of ships passed through it, with the only constraint being that the ship should not exceed the width, depth, and buoyancy conditions of the canal. But, over time, in an effort to maximize profit, companies designed what came to be called a Panamax ship: transport vessels that occupied every meter of the canal's lock system and container boxes that could be stacked tightly side by side.

Another great lesson bestowed on us by the anthropology of the gift was the insight that these figurated spaces were subtended and distended by time. Social theorists originally focused on the interval of time between the act of giving (credit) and the act of reciprocating (debt payment). Lévi-Strauss, for instance, argued that as men sought to expand their network advantageously, they developed increasingly complex temporal intervals between marriage givers and marriage takers.[18] Earlier, Marx attempted to understand the function of the interval between commodity production and money form, and exchange and use value. In his two-volume *The Civilizing Process*, the sociologist Norbert Elias argued that modern forms such as self-restraint, stranger sociality, and trust emerged out of increasingly complex networks of social connection across ever-vaster expanses or geographical social spaces.[19] As these increasingly complex exchanges unfolded across time and space, new social institutions (such as capital) came into being alongside their specific technologies (such as insurance).[20]

Bracketing debates in Marxism and anthropology over the differences and convergences between gift and commodity societies—such as the seeming differences of alienation, domination, and control (alienable versus inalienable objects, undisguised versus disguised domination, utilitarian versus moral controls, the reification of objects versus the personification of subjects)—one can understand the temptation to understand financial capital as a form of Kula exchange. Participants in the market seem to believe in the independent power of the market, similar to how participants in Kula believed in the power of Kula. And they believe in and trust the market even though—no more than Kula participants—beyond their local currents and eddies, market participants can have a striking understanding of complex networks and spheres that they create and participate in. Moreover, there seems to be a necessary relationship between the ignorance of trust and the cunning of information for the system to work. This is nowhere more profoundly demonstrated than in the recent financial crisis involving commercial mortgage-backed securities (CMBS). Even the critical understanding of the system as such doesn't guarantee a specific social outcome. If Marx sought to articulate a disenchantment with the black box of capital accumulation, countless speculators seek to beat the margin through a similar analytic acumen by creating new forms and networks, further complicating the circuit of capital and the spheres of its inhabitation.

At this point we must return to the real fundamental insight of the anthropology of the gift. While dramatic displays of wealth, such as Kula rituals and CMBS structures, might focus the social eye, "a greater number of secondary activities and

features" are done "under its cover." These other unperceived activities carried out in plain sight carry out the routine of creating the subjects who then take these Routes and Worlds as the best and most natural condition of *the world*. But no world is actual *one* world. The feeling that one lives in the best condition of the world unveils the intuition that there is always more than one world in the world *at any one time*. The very fact of Malinowski's presence, and his own argument that for the Trobrianders there were worlds within worlds, testifies to this claim. The material heterogeneity within any one sphere, and passing between any two spheres, allows new worlds to emerge and new networks to be added. This heterogeneity emerges in part because of the excesses and deficits arising from incommensurate and often competing interests within any given social space. These interests press materiality toward different futures even when operating within the same general social logic.

Take, for instance, the different futures pressing into the materiality of contemporary air transportation. The pressure of human transport capital is to cram an ever-increasing number of people into a limited space, while the pressure of agricapital is to increase the consumption habit of human beings, creating ever-larger human bodies. And both of these are subject to the speculative trade in oil and commodity futures driven as much by the gamble of bubbles as the logic of corporate functionality. But these futures are driven as much by the communicative networks that allow vast and high-speed trading as the slow production and life of the transportation industry. And here we return again to an insight gleaned from the gift: the potential futures internal to every actual world do not emerge willy-nilly. Debt/credit relationships tie up

and encumber the future with present obligations, and these obligations are literally carved into landscapes and subjects.

And it is here, in the excessive heterogeneity of social life, that the anthropology of the otherwise meets contemporary theories of Routes and Worlds, networks and spheres. Bataille is the name we usually associate with the critique of the economy of the gift as oriented to a balancing of accounts rather than radical expenditure, pure waste, or senseless excess. But the anthropology of the gift was also always an anthropology of an otherwise, and of radical deracination—of a part that has no part as of yet. Alongside their interests in gift economies, these anthropologists were also interested in the formless, in radical expenditure/deficit, and in the abject that exposed, escaped, or was produced by these systematizations of circulation and exchange. These excesses, deficiencies, and abscesses in the complex relationship between networks and spheres, Routes and Worlds, and the potential new worlds that emerge out of them has been the focus of two ongoing projects of mine.

Excesses and Deficits

For the last year, I have been working on a graphic memoir about the incommensurate social imaginaries that defined the relationship between my grandparents and me. Like many graphic memoirs, this one attempts to poetically condense a series of visual and written texts. It uses standard representational logics to probe a set of questions about how life-worlds ravel and unravel in the historical unfolding of empire, nation-state, and global capital, and how these ravelings and unravelings create new social imaginaries that may or may not develop

Elizabeth A. Povinelli, sketch from the graphic memoir *The Knifegrinder's Daughter*

the institutional supports to inflate and sustain themselves. Like other things, these gifts of memory move along specific routes, raveling and unraveling worlds in the process. Memory does or doesn't transfer across space (as organized kinds of places) and time (in the sense of generational logics), and it is here that we can see, perhaps most clearly, that gifts can be given long after the spherical world in which they make sense has collapsed. And gifts can return from a world not yet fully made to a world long since passed away. If these are the gifts of death, then gifts of death are indeed the condition for true beginnings.

The book is broken into three sections, "Topologies," "Mythologies," and "Analogies," and is written from the perspective of a six-to-eight-year-old girl. The first section, "Topologies," centers on an image in a frame that hung in my paternal grandparents' dining room. This image riveted my paternal relatives, causing fights, evoking tears, and staging long silences. The image itself was incomprehensible to me at the time. I would retrospectively learn that it was a topological rendering of the mountains of the Trentino–Alto Adige region. My paternal grandparents were born in a small village called Carisolo, just northwest of Trento in Italy, where their families had lived for countless generations. The Trentino–Alto Adige region was divided between the Austro-Hungarian Empire and the Italian state prior to the First World War, and incorporated into Italy only after the war. During the war, the region saw vicious trench warfare and mass slaughter, and my grandparents left soon after the war ended, taking with them a life-world that I could not see. For this reason, the image within the picture frame carried significant symbolic weight for them. Family fights would erupt when anyone would tack

down the referent of this sign. When I would ask my father what the picture meant (What's that? "That's where our village Carisolo is." Where's Carisolo? "It's in Italy."), my grandfather would fly into a fury that rippled across older relatives. But when my grandfather described what the picture portrayed ("That's our village Carisolo." Where's Carisolo? "It's in the Empire."), it failed to align with any of my known social cartographies.

The second section, "Mythologies," in turn presents the core myth of each of my grandparents. For instance, the condensed story of my maternal grandfather was that of his parents' attempt to survive in Alsace-Lorraine as hyperinflation was burning through the German Empire, which put him on a boat to the US with five dollars in his pocket. He was a gambler and womanizer as a young man, knocking up my mother's mother, marrying her, and then descending into extreme poverty. One day he won big at the horse races, bought a butcher's shop, got lung cancer, lived long enough to see my mother marry, and then died. The final section, "Analogies," shows how the small child attempts to make sense of this history in the 1960s in the racialized and racist American South.

Behind the drawings is a mediation on how *forms* and *practices* of sense become impractical as one sphere of life collapses into another—how a spherical world can continue to send out gifts of memory long after it has collapsed. The deformations and reformations of memory I try to capture here are possible because of the excesses and deficits that emerge as routes force open worlds and migrate objects (here subjects, my grandparents) into the midst of other worlds, creating embagged forms of life. In standard condensed graphic form, I can conjure the actual routes and localizations, the

embagination of world, the tensions internal to these new worlds because of networks already running through them, and the potential networks and worlds that emerge out of the unwindings and rewindings of memories in motion.

Augmented Reality

A second project on which I have been working focuses on the media and mediation of memory as memory travels across time and space, and the effect of this mediation on the worlds in which people dwell. In this case, very old Indigenous friends and colleagues and I are trying to build an augmented reality project that would allow access to stories about place, in places. The project started about five years ago, when new smartphone software such as 2D barcode-readers and GPS were just emerging to allow for augmented reality.

We were calling what we tried to envision "the mobile phone project," a digital project seeking to use mixed-reality technology to embed traditional, historical, and contemporary knowledge back into the landscape. More specifically, it would create a land-based "living library" by geotagging media files in such a way that they would be playable only within a certain proximity of a physical site. The idea was to develop software that creates three unique interfaces—for tourists, land management, and Indigenous families, the latter having management authority over the entire project and content—and provide a dynamic feedback loop for the input of new information and media. Imagine a tourist or one of our great-great-grandchildren in the same area. They open our website, which shows where a GPS-activated mixed-reality story is located. They download this information onto their smartphone. Now

imagine this same person floating off the shore of a pristine beach in Anson Bay. She activates her GPS and video camera and holds up her smartphone. As she moves the phone around she sees various hypertexts and video options available to her. Suddenly the land is speaking its history and culture without any long-term material impact on the landscape. And the person can only hear this story in the place from which it came.

I understand media as a demanding environment striated by other demanding environments (or, a complexly networked sphere). In other words, media, like the gift, is not an empty space but aggressive spacing within already existing Routes and Worlds. Media does not open itself up to make room for a new object so much as it makes a demand on how the object gives itself over to the spacing. More so perhaps than the graphic memoir project, this augmented reality project suggests how an anthropology of the otherwise encounters the excessive heterogeneity of contemporary Routes and Worlds, networks and spheres.

The project itself emerged out of noncorrespondence within settler colonial logics of domination. My Indigenous colleagues had spent their lives, as had their parents and grandparents, in a small rural Indigenous community across the Darwin harbor in Australia. They had grown up in the shadow of the land rights movement and the celebration of Indigenous cultural difference. Land rights and cultural recognition in Australia were exemplary of the logic of care in late liberalism—by making a space for traditional Indigenous culture, the state argued it was making a space for this traditional culture to care for Indigenous people.

However imperfect, this way of life started to unravel in 2007. As reported in the local Darwin

newspaper, on March 15, 2007, members of this project were threatened with chain saws and pipes, and watched as their cars and houses were torched and their dogs beaten to death. Four families lost rare, well-paying jobs in education, housing, and waterworks. Public meetings were held and were attended by the leaders of the Department of Family, Housing, Community Services, and Indigenous Affairs in the Northern Territory Labor government. In these meetings, the displaced people were held up as examples of the failures of land rights policies to protect Indigenous people living in communities outside their traditional country. The families driven out were promised new housing, schooling, and jobs at Bulgul, a site closer to their traditional countries. Fifty people promptly moved to Bulgul and set up a tent settlement.

But on June 21, 2007, John Howard, then prime minister of Australia, declared a "national emergency in relation to the abuse of children in Indigenous communities in the Northern Territory." Indigenous people living in remote communities, or those like my friends who were promised housing in or nearer to their traditional country, were told to move closer to the cities where infrastructural and service delivery costs were lower, even if doing so would endanger their lives. The people who made the promises to the displaced persons confronted the budgetary consequences of these promises and suddenly became difficult to reach. In the year that followed, the income of two of the six families driven off went from roughly $AUD28,000 to $AUD12,000 per year after they lost their permanent jobs and were moved onto the Community Development Employment Program (CDEP, a work and training program within a social welfare framework, loosely called "work for the dole").

If this project emerged out of the material and discursive networks that moved my colleagues across social landscapes, then the communicative sphere into which they sought to insert their modes of memory and memorialization retain their own forms of reflexive movement and figurating force. I will mention only three. First, all objects that are placed into our augmented reality project are treated according to specific software routes that create semantic worldings. No matter which semantic ideology underpins this routing—such as the new Web Ontology Language (OWL)—it nevertheless demands that the entextualized memory and knowledge conform to it. Second, although many postcolonial archives and digital projects seek to develop software that would encode local protocols of information circulation and retrieval—such as restrictions based on kinship, gender, or ritual status—it remains that, in order to be part of the global condition of the contemporary internet, such information must be universally available before it can be sorted based on user particularities. In other words, user protocols—the software that takes into account local social principles of circulation and retrieval—are always secondary and subordinate to the infrastructure of the web itself. Finally, the ability to hinge information to place is mediated by a specific set of demanding environments and the institutions that support them.

But remember: all embagged spaces are the result of not merely two strings hanging from the end of an open, if concealed mouth, but many strings tying and retying the body and its contents.

1
The names we would usually attach to the Möbius strip, rhizome, and parasite are, respectively, Jacques Lacan, Gilles Deleuze, and Michel Serres.

2
See George W. Stocking Jr., "Maclay, Kubary, Malinowski: Archetypes from the Dreamtime of Anthropology," in *Colonial Situations: Essays in the Contextualizations of Knowledge*, ed. George W. Stocking Jr. (Madison: University of Wisconsin Press, 1993), 212–75.

3
Annette Weiner, *Inalienable Possessions* (Berkeley: University of California Press, 1992).

4
Bronislaw Malinowski, *Argonauts of the Western Pacific* (Long Grove, IL: Waveland Press, 1984).

5
What constitutes this demise need not be the loss of the carrying materiality. A new "body" to carry the spirit of the gift can be fabricated without the *thing* being lost.

6
Marcel Mauss notes early on that Kula is the ritualized expression of the hierarchy of values created through "a vast system of services rendered and reciprocated, which indeed seems to embrace the whole of Trobriand economic and civil life." Marcel Mauss, *The Gift* (New York: Norton, 2000), 34.

7
Gustav Peebles. "The Anthropology of Credit and Debt," *Annual Review of Anthropology* 39 (2010): 225–40.

8
Mauss, *The Gift*, 35–36.

9
We should also not be lulled by the semantic weight of the English terms "participants" and "participation" (*participare*). Because the world Kula makes is there before the participant enters into it, to participate is a demand.

10
See Peebles, "Anthropology of Credit and Debt."

11
See, for instance, Nancy Hartsock, *Money, Sex, and Power: Toward a Feminist Historical Materialism* (Boston: Northeastern University Press, 1986); Marilyn Strathern, *The Gender of the Gift* (Berkeley: University of California Press, 1990).

12
Peter Sloterdijk, *Bubbles: Spheres, Volume I: Microspherology* (Los Angeles: Semiotext(e), 2011).

13
I understand a life-world as a space of inhabitable existence. See also Bruno Latour, "Some Experiments in Art and Politics," *e-flux journal*, no. 23 (March 2011).

14
See, for instance, Gayle Rubin's two seminal essays, "The Traffic in Women: Notes on the 'Political Economy' of Sex," in *Toward an Anthropology of Women*, ed. Rayna Reiter (New York: Monthly Review Press, 1975); and "Thinking Sex: Notes for a Radical Theory of the Politics of Sexuality," in *Pleasure and Danger*, ed. Carole Vance (London: Routledge & Kegan Paul, 1984).

15
See Talal Asad, ed., *Anthropology and the Colonial Encounter* (Amherst, MA: Prometheus Books, 1995).

16
See Benjamin Lee and Edward Lipuma, "Cultures of Circulation: The Imaginations of Modernity," *Public Culture* 14 (January 2002): 191–213.

17
See Dilip Parameshwar Gaonkar and Elizabeth A. Povinelli, "Technologies of Public Form: Circulation, Transfiguration, Recognition," *Public Culture* 15 (March 2003): 385–98.

18
Claude Lévi-Strauss, *Elementary Structures of Kinship* (Boston: Beacon Press, 1971).

19
Norbert Elias, *The Civilizing Process: Sociogenetic and Psychogenetic Investigations* (London: Wiley-Blackwell, 2000). More recently, Mary Poovey has examined the rhetorics of finance that supported the elaborate and geographically extensive networks of sixteenth- and seventeenth-century Western European finance. See Mary Poovey, "Writing about Finance in Victorian England: Disclosure and Secrecy in the Culture of Investment," *Victorian Studies* 45 (January 2000): 17–41.

20
Lorraine J. Daston, "The Domestication of Risk: Mathematical Probability and Insurance, 1650–1830," in *The Probabilistic Revolution, Volume 1: Ideas in History*, ed. Lorenz Kruger, Lorraine J. Daston, and Michael Heidelberger (Cambridge, MA: MIT Press, 1987), 237–60.

After the Last Man: Images and Ethics of Becoming Otherwise

Politics and art, like forms of knowledge, construct "fictions," that is to say *material* rearrangements of signs and images, relationships between what is seen and what is said, between what is done and what can be done ... They draft maps of the visible, trajectories between the visible and the sayable, relationships between modes of being, modes of saying, and modes of doing and making.
— Jacques Rancière, *The Distribution of the Sensible*[1]

Huddled within one of the most influential theories of human desire and the destiny of democracy is an image of history and its future. This image is of a horizon. In lectures delivered at the École pratique des hautes études from 1933 to 1939, Alexandre Kojève argued that the horizon of universal human recognition ("democracy") was already in the nature of human desire but, paradoxically, had to be achieved through concrete struggles that intensified political life. These struggles were dependent on and waged against the background of human finitude. Yet, at the end of these battles, when the horizon had been breached, the world and the humans within it would be a form of the undead.

What *was* the future of this image? And what is its future now? Is it "huddled within," or is it the architectural framework on which affective and institutional futures were built and now face us? What other imagistic architecture of human being and politics might have made an alternative history and future of political action? Here I extend a set of thoughts first published in a previous essay on a very different image and grammar of social and political life—the bag and embagination.[2] What would happen if we replaced the transcendental architecture

of the horizon with the immanent architecture of embagination? And how is embagination not replacing other images of immanent becoming—the fold and the rhizome—but rather confronting them?

1

We can begin with the fall of a wall and a set of proclamations that followed. That is, the difference between the fall of the Berlin Wall and claims about the meaning of this material collapse. Who better to illustrate this difference than Francis Fukuyama? In *The End of History and the Last Man* (1992), Fukuyama asserted that the fall of the Berlin Wall demonstrated that "a remarkable consensus concerning the legitimacy of liberal democracy as a system of government had emerged throughout the world over the past few years, as it conquered rival ideologies like hereditary monarchy, fascism, and most recently communism."[3] For Fukuyama, liberal democracy—we might also say "neoliberal capitalism"—constituted the "end point of mankind's ideological evolution" and the "final form of human government."[4] As such, it marked the "end of history" and the emergence of "the last man."

Fukuyama was a student of Allan Bloom and a disciple of Leo Strauss, two prominent intellectual leaders of the neoconservative movement in the US. But to understand what is at stake in Fukuyama's proclamation about the "end of history," we must travel across the Atlantic and back in time. Fukuyama's reading of this material collapse depends on the philosopher Alexandre Kojève's reading of Hegel's *Phenomenology of Spirit*.[5] Interpreting Hegel through Marx, Nietzsche, and Heidegger, Kojève argued that the history of humankind would come to an end when equal recognition had been universalized in the form of liberal

democracy. Why? Because the desire for recognition is what differentiates human and nonhuman animals—what defines the human *qua* human—and constitutes the motive force of history.

Much depends on the difference between animal and human desire. The animal—and the animal part of man—becomes aware of itself as it experiences a desire, such as the desire for food, which is the consequence of finding itself in a state of hunger. This state of hunger creates in the animal a sentiment of self, a rudimentary "I" that says, "I am hungry." In this sense, desire is empty: desire is the experience of lack. This experience of emptiness is, however, a positive force, for it rouses and disquiets being, moving it from passivity into action. In other words, desire creates in human and nonhuman animals a "sentiment of self": an awareness of the existence of the self as an "I" at the moment when the emptiness of desire asserts itself over being.

But whereas animal desire satisfies itself merely by consuming what is in the world, human desire looks beyond what is already at hand. For Kojève, the differentiating mark of the human—what makes man a *human* animal; his "anthropological machinery," to paraphrase Agamben—is that his desire doesn't seek something that already exists in the world but something that doesn't *yet* exist.[6] Human desire is doubly empty. It is awakened by the experience of a lack, but the form of satisfaction it seeks goes beyond the given world of things, forms, affects, and so forth. What might this nonexistent object of desire be? According to Kojève, it can only be another human's desire, equally as empty and as ravenous for satisfaction. This is the atomic kernel of the battle for recognition: the desire is to be the object of another's desire. I want to be what you want. What I want is to have you want "me." And "me"

is what I desire to be in the world, my vision of the world. You want me to do the same, and thus there is a battle over whose vision will prevail. It is this duel between the ravenous empty dualities of desire that leads to the intensification of politics and is the motive force of human history.

From this simple diagram of desire and recognition comes the material dialectical unfolding of the world of liberal democracy—or neoliberal capitalism—which begins in the confrontation that produces the master-slave relationship and ends in the universalization of equal recognition. The battle of recognition, which is a battle to be the object of the other's desire, is what for Kojève intensifies political and social life and thrusts the human being toward the horizon to which human history has always been leading—namely, a form of governance in which recognition is mutual and universal. Most importantly, Kojève did what Kojève theorized. He put his theory into practice through specific bureaucratic battles to institutionally shape the political and economic world of Europe and the US.[7] Kojève *materialized* a theoretical image (imaginary) by seducing others into thinking his desire was their desire—and that this desire was the truth of the future in the present and not merely one image among many of human being and history.

But if the dominant image of this theory of desire and democracy begins as a horizon, it ends as something very different. If liberal democracy is the *horizon* of desire already inscribed in the fight for recognition (the orientation and end of human becoming, and thus the end of history itself), then when liberal democracy has been universally achieved, human historical becoming collapses into a satisfied human state of being. The horizon then becomes what I will call a *surround*, a form of

enclosure without a wall or gate. The surround is without an opening. It is an infinity of homogeneous space and time. It is an "everywhere at the same time" and a "nowhere else." One can go here or there in the surround, but it really makes no difference because there are no meaningful distinctions left to orient oneself toward—to determine where one goes or what one believes or holds true. To paraphrase Nietzsche, there is no shepherd or herd in the surround. Everyone wants the same because they are the same. Even the hope of the madhouse, as the place where difference is interned, is lost because difference no longer exists.[8]

But when I say "the human in the surround," I misspeak. When humankind finally reaches the horizon it has been producing through the battle for recognition, the thing that emerges is not the same thing that had created it. What had distinguished humans from nonhuman animals changes. The thing that inhabits the surround is not an animal. But it is also not human. The Last Man is the end of Man. The surround is inhabited by what Agamben calls a "nonhuman human," something that seems quite similar to the contemporary televisual obsession with the undead—a kind of being which is deceased and yet behaves as if it were alive. Kojève and his students understood this. In losing the horizon of desire, man became a kind of post-man. When the wall falls and the horizon collapses, man receives the package he had sent himself when first starting out on his journey. But the recipient is as foreign to the human who sent the package as the human was from the animal.

In debating what was the sensuous and affective nature of the last man left in history's wake, Kojève and his students demonstrated how thoroughly they themselves had become dominated by their own dominant image. Kojève described the

affect of the Last Man as satisfaction, which he distinguished absolutely from enjoyment. Raymond Queneau tried to capture the existential state of satisfaction in his novels, and Georges Bataille attempted to find some way of intensifying life in the surround of satisfaction through blood and sacrifice, entrails and excrement. But rather than determining the sensuous affect of this state of being in the surround, Kojève, as well as his bureaucratic colleagues and his students, used theory, literature, and bureaucratic practice to materialize the image as a circuitry connecting institutions, significations, and affects in such a way that they produce hopes and expectations, disappointments and rage—and perhaps most important for a critical politics—senses of justice and the good. And lest we think our political imaginaries have transcended this image, we can turn to Lee Edelman's scathing critique of *Children of Men*, a film which assumes that without the future as a horizon of being, figured in the promissory note of the child, all pleasure and drive would collapse like so much air in a punctured balloon.[9]

And here I think we can see how a dominant image of human history, and human *political intensification* in particular, has come to dominate human becoming. It does not matter whether the horizon is out there in a reachable or unreachable form. It does not matter whether the horizon is there before we start our journey or is constituted from the activity of walking. It does not matter whether the horizon is figured as a wall, a frontier, a checkpoint, or a fence. The human production of an image of human becoming and being as a future in which a limit—or condition—has been achieved has led to a reduction of our capacity to imagine alternative images of human becoming.

While we might not agree with Rancière's aesthetic periodizations, his understanding of the politics of aesthetics as the entanglements of power and visibility and of sensuous embodiment, of affects and energies, is right. Images of history have a habituated *feeling* to them.

The habituated affects of the image of a horizon were on full display in two material collapses that occurred decades after the fall of the Berlin Wall. Dominated by the image of the horizon of history, what wonder then that 9/11 and 2008 were *exciting*, not merely *dangerous*, moments? Perhaps history had not ended, perhaps a limit, a front, a back, a horizon, and a border had miraculously appeared in the "clash of civilizations" and the crash of the financial markets, and with them an opening, a gate, a direction, a movement of becoming. Perhaps universal recognition either had not arrived in the form of Western democracy, or this system had a radical new context in which to unfurl its form, meaning, and legitimacy. Maybe we were not in a *surround* but were instead surrounded by something that could be overcome. Maybe something could still be done. Note how these questions do not disturb the political imaginary of recognition so much as they merely change its clock.

Events since 9/11 and 2008 have not supported this hope. Being remains enclosed, if not by a political form of government (democracy), then by an economic form of compulsion. Celebrations of a democratic spring across the Arab world were soon followed by the installation of technocratic rulers in Italy and Greece, with global pundits celebrating the ability to bypass the democratic function. And in China, the supposed inevitable conjoint of liberal market and government remains a receding horizon as the country's economic power seems ceaselessly

to expand. Rather than neoliberal finance unveiling its internal limits in a global market, democracy has all but given way throughout Europe and has never seemed to be needed in China. If democracy is the back of history, there seems to be no front to neoliberal being. How do we think about the sources of the political otherwise when being seems trapped in an enclosure rather than having a front or a back? Where are the sensuous modes of becoming within the global circulations of being that have defined modern politics and markets, if not in a *horizon*?

2

For some time now scholars have been thinking about the concept of circulation in relationship to the making and extinguishing of social worlds. Why do some forms move or get moved along? What are the formal/figurative demands placed on forms as the condition of their circulation in and across social space? What are the materialities of form that emerge from, and brace, these movements, and that make "things" palpable and recognizable inside the contexts into which they are inserted? And finally, how is social space itself the effect of competing forms and formations of circulation?

Given the profound influence of my Indigenous colleagues and friends on my thinking, it is no surprise that the dominant image of circulation I have is of a string bag, or *wargarthi* in Emmiyengal, an Indigenous language of the northwest coast of Australia. A string bag is formed through a reflexive, dense to semi-dense weave. It is capable of dynamic expansion and contraction and has a load-sensitive shaping. The string bag has a formal mouth but the body is composed of openings that can anchor new weavings or ensnare objects. (The same basic weave and technology is used to

make fishnets.) And, depending on their material composition, these bags are likely to decompose in different ways under different conditions. In other words, the string bag is a mode of circulation insofar as it is a *reflexive form* with *figurative material force* that constitutes and obligates everything in and between it, and yet it is shaped by that which it tries to contain and can be reshaped by tying new strings and anchors into its body. It is the string bag I see in Tomás Saraceno's architectural environments and Mark Lombardi's drawings of the social networks that compose modern power.

But bags are only experienced as bags—as something capable of holding something else—when the things that fit into them fit in a more or less compatible way. Thus we might think of the functionality of bags as dependent on the things that will enter them. But what if we thought of embagination as the process by which things themselves come into being and then come to have a residence, a domicile? What if the formations of a specific form of reflexive movement were the conditions in which new life-forms emerged and found domicile—though at the price of extinguishing other forms?

In *Playing and Reality*, the British psychoanalyst Donald W. Winnicott describes the case of a young boy of seven who had "become obsessed with everything to do with string."[10] Not string per se, but what string seemed to allow him to overcome—the separation of objects due to a diminution of the forces that had previously held them together. Whenever his parents would enter a room, "they were liable to find that he had joined together chairs and tables; and they might find a cushion, for instance, with string joining it to the fireplace." The parents only became disturbed, rather than simply bemused, when a "new feature"

of his tethering practices emerged. "He had recently tied a string around his sister's neck."[11]

For Winnicott, these elaborate webs were "transitional objects" that manifested the young boy's denial of maternal separation.[12] His patient used string to reintegrate material that was on the threshold of disintegration and to confine the forces responsible for the disintegration. Thus the string tied around his baby sister, the object that posed the first serious threat to his bond with his mother.[13]

Winnicott first became aware of the psychic side of the boy's obsession during a "squiggle game." In his work with children, Winnicott would draw a squiggle and ask the child to complete the drawing. In the represented space of Winnicott's notebook, the young boy's creations looked like webs, but in the lived space of the boy's home the webs were more like badly constructed bags. He *embagged* space as he wove together new object forms and dependencies, hoping to save a world he had already lost. In the process he conditioned how things could move in and through this new world; how things—such as himself—could be held in it; and whether things—such as himself or his sister—could exist in it. What resulted was neither what had been nor what currently was. Nothing he did could undo the damage done by the arrival of his sister. But in trying, the boy created new habitations, new ways of being held. He did not mean to do this, but his refusal was a creative act. It provided an environment for alternative possibilities of life. Cushions were no longer able to be manipulated, visibly or tangibly, independent of the fireplace. The fireplace now had the cushions as one of its internal organs. The cushions had the bricks. Winnicott's job was to normalize these possible trajectories—impose on them the proper image of singularities, difference, and development.

The thresholds of being and separation that the boy saw and the new thresholds of being he created are the same thresholds that many adults come to forget, repress, or attempt to destroy—or perhaps they give them a clinical diagnostic such as the persistent denial of reality. Adults accept a given assemblage as natural to the world, and experience this assemblage as a preexisting collection of objects and subjects independent of the embagged space that has created it. As such, it is little wonder that many adults see these object/subjects as the anchor around which other things are tied. But the boy had an intuition, or an irritation, that the cushion and fireplace were not there first, nor the string after, but are themselves effects of a kind of tethering whose conditions he does not understand and whose immanent undoing he is equally at a loss to explain. The boy knows that the world he has inhabited—which has securely held him— will no longer be habitable if the underlying woven pattern takes on a new form. So he uses string as a form of communication in an older sense of *intercourse*—a *reflexive form* with *figurative force* that mutually constitutes and obligates everything in and between it. His sister probably experienced this intercourse as a kind of stranglehold. But the boy finds himself in a bind. From his perspective, her arrival has created a new circuit of care that is suffocating him. He knows it takes force to hold something in place. The boy sees his options as either to strangle or be suffocated.

Winnicott may have thought his young patient was using his strings to slowly reconcile himself to the natural progression of maturation. But the young boy intuited that demanding environments are not held in place by the natural order of things. They are historical arrangements (*agencements*)

that depend on a host of historically formed interlocking concepts, materials, and forces that include human and nonhuman agencies and concepts. Because we are merely one mode of being in one location of being, we cannot and will never be able to understand or explain the conditions that make up our world or what causes its immanent undoing. Thus, as we try to secure it—or to remake it—we create and extinguish. And, like this young boy, the reflexive movements shaping space nonetheless have a figurative force. Our spaces sag, impede, irritate, or scare others.

In other words, in trying to secure or disturb a world, we also do two additional things. On the one hand, we mark the itinerary of our desire as an obligation to something rather than a battle for recognition for something, as a composition and decomposition, but without the dominating image of a horizon. On the other hand, we extinguish one world in the very act of trying to keep another world in place, to return to this place, or to create new places. And this second point is crucial: the topologies we compose to hold and give domicile always have the figure of the sister as their ethical counterpoint.

3

Since the late 1960s a number of images have challenged the dominance of the dialectical horizon—especially Deleuze's image of the fold and Guattari's image of the rhizome. Deleuze saw the image of the fold as combating a model of subjectivity and being that contrasted forms of interiority and exteriority, or placed them in dialectical tension. For Deleuze, the interior of being does not come up to an edge, border, or frontier that defines what is outside itself. Rather, interiority is itself complexly

composed of "forces of the outside." All interiority can be understood as *extimate* ("extimité"), a term Lacan coined in order to describe the intimate exterior.[14] Deleuze extends the concept of the extimate outside human subjectivity, making it a general condition of all entities. In other words, at the heart of an assemblage—the subject-objects that the parents of Winnicott's patient assumed to preexist their child's string play, or the subject-objects that will emerge from it—is this folding of the external into the intimate internal. In some way the rhizome simply provides an organic foundation to, and elaboration of, the image of the fold.

Unlike arboreal images, a rhizome can be severed and yet still be productive. But most importantly for Deleuze and Guattari, the rhizome represents radical potentiality existing on the plane of pure immanence. "Unlike the graphic arts, drawing, or photography, unlike tracings, the rhizome pertains to a map that must be produced, constructed, a map that is always detachable, connectable, reversible, modifiable, and has multiple entranceways and exits and its own lines of flight."[15] There is no horizon simultaneously within the rhizome and toward which it inexorably moves.

Insofar as this image conjures the hope for a radical potentiality that exists on the plane of pure immanence, it is in line with Deleuze's long engagement with Spinoza—more specifically, his reworking of Spinoza's concepts of *conatus* and *affectus*. Deleuze is not the only one who has reevaluated these key concepts of Spinoza. Weaving together the writings of Deleuze and Irigaray, Rosi Braidotti has noted the "implicit positivity" of the "notion of desire as *conatus*," and through it a new form of politics.[16] For Deleuze and Guattari, this implicit positivity dwells not merely in all actual things,

but also in all potential things—the body with organs and the body-without-organs within every organic arrangement.[17] And in his effort to develop a positive form of biopower, Roberto Esposito has recently linked Spinoza's notion of *conatus* to his claim in the *Political Treatise* that "every natural thing has as much right from Nature as it has power to exist and to act."[18]

It is exactly here that the images of the fold and the rhizome have lost their political nerve, and we return to our little boy madly tying together various pieces of his domicile in a perhaps desperate attempt to return it to its previous form and in that form find a dwelling. Note that Esposito places the emphasis on "the intrinsic modality that life assumes in the expression of its own unrestrainable power to exist" rather than on what might be a more Nietzschean reading, namely, the relative power that *restrains* the existence and actions of various bioformations in a given field of often opposing striving actors (actants).[19] What if one striving potentiating meets and opposes another? Can progressive politics avoid this question—and thus the problem of extinguishment? How would the sign "progressive" read if it were understood as always actively maintaining, producing, and *extinguishing* worlds? In its refusal of the repressive hypothesis, how has progressive politics avoided the politics of its own practice's extinguishment, and in avoiding these politics, lost its ethical depth?

The problem is especially acute if we do not return to the image of the horizon already within us that nonetheless necessitates a building. This image of the horizon elevates into transcendental truth a kind of affect (a combative desire for the desire of the other), a form of life (universal recognition), and a shape of governance (liberal democracy).

All is adjudicated from the perspective of these cardinal measures. The fold and the rhizome were meant as a politics and ethics grounded on radical immanence—the becoming community—in which "immanence is no longer immanence to anything other than itself."[20] Pure immanence is a life—not to life or the life. All forms of life are immanent in this sense and all life is a form of life. This is what Winnicott's patient intuited and desired: *a* life, not life. But his sister sat to one side. From her side of the room, his attempt to potentiate a life threatened her own, or more precisely, the form of life that was her life at that point. How much more intense might the conflicting embaginations be when the life that is a life is more fully formed, elaborated, self-aware? When the girl is the boy become a man? When the seedling is the plant that becomes the rain forest that my friend dreams of finding amid a growing web of deforestation from multinational mining?

What are the ethical grounds of these conflicting forces of embagination against a background of finitude that is without transcendental value? In my previous essay on Routes and Worlds I tried to suggest how the material heterogeneity within any one sphere, and passing between any two spheres, allows new worlds to emerge and new networks to be added. This heterogeneity emerges in part because of the excesses and deficits arising from incommensurate and often competing interests within any given social space. But these heterogeneities and their "interests" press materiality toward different fabricated futures. How can we imagine pure immanence and radical potentiality without becoming blind to the extinguishments of forms of life that every actual world entails?

1
Jacques Rancière, *The Politics of Aesthetics: The Distribution of the Sensible*, trans. Gabriel Rockhill (London: Continuum, 2004), 39.

2
See Elizabeth A. Povinelli, "Routes/Worlds," in this volume.

3
Francis Fukuyama, *The End of History and the Last Man* (New York: Harper Perennial, 1993), xi.

4
Ibid.

5
Alexandre Kojève, *An Introduction to a Reading of Hegel: Lectures on the Phenomenology of Spirit*, trans. James H. Nichols (Ithaca, NY: Cornell University Press, 1980).

6
Giorgio Agamben, *The Open: Man and Animal*, trans. Kevin Attell (Stanford, CA: Stanford University Press, 2003).

7
After the Second World War, Kojève left his position at the École pratique des hautes études and took up a position in the French Ministry of Economic Affairs, where he was one of the chief ideologues for the European Common Market, the bureaucratic predecessor of the European Union. See Dominique Auffret, *Alexander Kojève: La philosophie, l'État, la fin de l'Histoire* (Paris: Grasset, 1993).

8
Friedrich Nietzsche, *Thus Spoke Zarathustra*, trans. Adrian Del Caro (Cambridge: Cambridge University Press, 2006). Given Fukuyama's mutual admiration of Kojève and Leo Strauss, it is important to note that these two disagreed about the inherent difference between philosophy and politics and the goal of mutual recognition. See Leo Strauss, *On Tyranny* (Chicago: University of Chicago Press, 2000).

9
Lee Edelman, *No Future: Queer Theory and the Death Drive* (Durham, NC: Duke University Press, 2004).

10
Donald W. Winnicott, *Playing and Reality* (London: Routledge, 1982), 17.

11
Ibid.

12
Donald W. Winnicott, "Transitional Objects and Transitional Phenomena," *International Journal of Psychoanalysis* 34 (1953): 89–97.

13
Winnicott, *Playing and Reality*, 19.

14
In an essay on the extimate, Jacques-Alain Miller describes the intimate as parasitic on the externality of the Other. See Jacques-Alain Miller, "Extimity," *The Symptom* 9 (2008).

15
Gilles Deleuze and Félix Guattari, *A Thousand Plateaus: Capitalism and Schizophrenia*, trans. Brian Massumi (Minneapolis: University of Minnesota Press, 1987), 21.

16
Rosi Braidotti, *Transpositions: On Nomadic Ethics* (London: Polity Press, 2006), 150.

17
Gilles Deleuze, *Foucault*, trans. Sean Hand (Minneapolis: University of Minnesota Press, 1988).

18
Roberto Esposito, *Bios: Biopolitics and Philosophy* (Minneapolis: University of Minnesota Press, 2008).

19
Ibid., 185–86.

20
Gilles Deleuze, *Pure Immanence: Essays on a Life*, trans. Anne Boyman (New York: Zone Books, 2001), 27.

Horizons and Frontiers, Late Liberal Territoriality, and Toxic Habitats

Elizabeth A. Povinelli

Routes/Worlds

Two imaginaries of space have played a crucial role in the emergence of liberalism and its diasporic imperial and colonial forms, and have grounded its disavowal of its own ongoing violence. On the one hand is the horizon and on the other is the frontier. These two spatial imaginaries have provided the conditions in which liberalism—in both its emergent form and its contemporary late form—has dodged accusations that its truth is best understood from a long history and ongoing set of violent extractions, abandonments, and erasures of other forms of existence, and have enabled liberalism to deny what it must eventually accept as its own violence. The horizon and the frontier: these two topological fantasies anchor the supposed world-historical difference between liberal governance, as a putative normative orientation and specific rule of law, and all other past and possible future forms of relationality. Let us tackle first the horizon as a sine qua non of liberalism's toxic inhabitation.

Ah, the horizon: Jürgen Habermas captures the hold it has on liberal reason: "Horizons are open, and they shift; we enter into them and they in turn move with us."[1] They might be historical horizons within one community, or the translational possibilities between two or more—both are where the truth of liberalism lies.[2] There are facts, as Habermas says, and there are norms. And it is in the norms, or in the measure between the facts and the norms, that liberalism claims its world-historical exception from other state forms of violence. But tell that to those who are subject to liberal facticity. They will respond that this ever receding vista of liberal norm is the liberal fact—indeed fact after fact shows no such norm exists in fact. Instead of a norm, the horizon is the deployment of a spatial imaginary to bracket all forms of violence as the result of the

unintended, accidental, and unfortunate unfolding of liberalism's own dialectic. The use of portraits of Indigenous peoples and Black and brown bodies as mental and social savages that has justified the appropriation of lives, the extermination of bodies, and the destruction of lands: liberal apologies finally uttered in statements that describe these violent representations and actions as aberrations of its own ideals. The vicious absorption of entire worlds into the logics of liberal capitalism: the apology that it should have been done more gently and with more cultural and social sensitivity. Or as Christina Sharpe suggests, the liberal horizon is in fact the wake where African men, women, and children struggle to find possibility in the impossible after-space of the transatlantic slave trade, in which liberal capital claimed to be traveling toward a new ideal man.[3]

In *Economies of Abandonment*, I described these worlds of existence that are forced to find their way in the forsaken and disavowed liberal space between fact and norm as inhabitants of the brackets of late liberalism.[4] For them the "accidents" and "exceptions" define liberalism when the horizon is withdrawn. For them the problem is not that they are not allowed to reach the norm but that there is no actual norm. Instead, the ideal-norm is what allows liberalism to act with impunity in the present, what allows liberalism to believe that its acts of violence are justifiable or unintentionally unjust. The cunning of recognition is one mode in which this maneuver unfolds.[5] After decades of anti-colonial and radical social critique ripped apart the justificatory surface of liberalism's claim to be sacking worlds in order to extend civilization, liberal recognition apologized and proclaimed its desire to hear and find worthy the massive crowds of existence that it had previously interned in the

exception. And like neoliberal economics, liberalism shifted the burden of the care of the self away from itself and onto those it has already harmed, in a doublespeak that imposed a double bind onto the legally enunciative possibilities of others. *Just tell us your cultural and social values. Just don't tell us anything that will actually threaten the "skeleton of principle which gives the body of our law its shape and internal consistency."*[6] This doublespeak double bind of recognition—this revised horizon of the Human—marks all others as *having been let in*. This mark genders and racializes the bodies of all excluded from the horizon of whiteness, a point Frantz Fanon made long ago and that has been more recently discussed by Denise Ferreira da Silva.[7]

In short, the horizon is not the End of a certain Man but a mechanism by which a specific violent history of some men is kept from ever landing. Even the Man doesn't actually want to arrive in the land the horizon hopes for. If he lands he will be no different than any other form of existence. Worse, he thinks, he will be worse off without this simmering distinction he once had but has now lost. Others will not lose this fantasy, because it was never theirs. How quickly then do we see any announcement of an actual End of History excitedly announced to have been a mirage?[8] The Spirit lives on, violently unfolding its own inner horizon temporally and spatially. Let us hitch a ride with Elon Musk to Mars my friends, to Mars. There we can once again disavow the toxic destruction of existence far away on a long-forgotten earth. And here we catch a glimpse of how the horizon can be easily transformed into a frontier. Thus it is not surprising to find liberal political theory speaking equally of justice, law, science, and social difference as both horizon and frontier. Both are the toward-which the spirit of a certain kind of man soars,

powered by fear of the toxicity he has produced and left behind in so many sacked worlds.[9] And thus we come to the frontier and its dynamics.

The frontier has, of course, a specific linguistic and social etiology, dating from fifteenth-century French, referring to the place where two countries meet, the abutting edges of sovereign lands. Later the frontier would be absorbed into Anglo diasporic discourse and law as the contested space between civilized and uncivilized natures and cultures. Thus the frontier moved, in discourse, from a space between two sovereign powers to the space between civilization's sovereignty and the terror of barbarity. It is where the sovereignty of civilization might be upended by other nonsocial imaginaries. No matter Foucault's partition in the modes of governance (sovereignty on the one side and discipline and biopolitics on the other)—it matters little what form liberal governance takes when it peers over the horizon of the colonial frontier. Nor does it matter whether we use Schmitt's marking of 1492 as the date when the *nomos* of the world emerged as Europe used various flags to territorialize the earth, or whether we insist that it was only with the globalization of neoliberal capitalism that this global nomos settled in. In all of these cases, what matters for those on the other side of liberalism's claim that it acts violently only when civilization is at stake, or only when it is mistaken in its understanding of the cultural and social qualities that exist on the other side of the frontier, is that a power is seeking to advance an ever larger territoriality of rule.

It is the view from the other side that first critiques the sovereign, his sovereign powers, and its ancient theorists—Jean Bodin, Hugo Grotius, and Thomas Hobbes. And it is from spaces such as Critical Indigenous Theory that a demand for an

exit route from more modern theorists, such as Carl Schmitt and Giorgio Agamben, can be imagined. Western political theory has used sovereignty figures to create the frontier in discourses of law and discovery, of war and expansion, of empire and its liberation, which in turn transform space into a contest between rulers or a contestation between the ruled and the unruly. In both frontiers the physics of this megalomaniacal vision of sovereign expanse across a frontier is Newtonian. It is the physics of bodies at rest or motion, of opposing forces, of equal and opposite reactions. But between rulers the frontier should be a border where reactions should end, where the politics of peace should reign. Once the war has been won, the frontier secured, the politics of sovereign peace keeps all bodies in their proper place. All bodies that oppose internal rule are the disruptors of peace, terrorists. Thus terrorists can come from anywhere, from the middle, the edges, from nowhere. They create strange interior frontiers—the slum and the ghetto, the internet and the whistle-blower—because the frontier emerges whenever borders are punctured or perforated, are not secured or recognized.

Even a secure border between rulers is a notional frontier not only because, no matter how precise the demarcation, some material space must hold the demarcating difference between here and there and between them and us, but also because a border and frontier are effects and affects of a specific political theology—a belief that absorbed the realm of the divine into the function of the lawful border. A worldwide territorial order had a heavenly seal, a spirit of justice with its own centers, peripheries, and frontiers. Thus Haiti could be within France, and yet where the application of the rights of man were concerned, it was a frontier. The British

could massacre and mourn those who were in the Americas and Australia before it arrived with its right to create a sovereign order over a lawless expanse. And the Monroe Doctrine allowed the US to declare frontier spheres within spheres of its own domination. The sovereign law decides what is border and what is frontier, when one becomes the other, when the energies accumulating in the space where two bodies are pressing against each other should be bracketed or liberated so once again opposing forces and reactions can be set in motion. There is no left or right to this model. There is only this position against that—your space and time against mine.

Many theorists have struggled to describe the space on the other side of the frontier—whether internal or external, whether spaces emerging in the wake and the brackets of recognition—as containing within them something other than an immanent sovereignty. How finally to think power and space without frontiers and horizons? Perhaps the most widely embraced answer has been to think with Deleuze and Guattari's concept of the rhizome. After all the rhizome, in form and dynamic, as Deleuze and Guattari argued, is a decentered network analytically exploring space as a method of unfolding itself: "Unlike a structure, which is defined by a set of points and positions ... the rhizome is made only of lines: lines of segmentarity and stratification as its dimensions, and the line of flight or deterritorialization as the maximum dimension after which the multiplicity undergoes metamorphosis, changes in nature."[10] Karen Barad sees the rhizome as allowing a quantum understanding of political and ethical rule.[11] The rhizomatic frontier is organic, mechanic, and quantum—a hunk of ginger and swarming ants; the internet; the "now you see it and now you don't" nature of Schrödinger's cat. The root can

be broken, the nest scattered, data routes closed, objects disturbed by quantum logics. But each will start again—the root now has two separate surfaces through which it can reconstitute and expand itself; the ants set off in search of new crevices; the hacker opens portals; the cat grins. The rhizome does not mind the lattice because it provides a condition for spatially unfolding. Put anything in its way and the rhizome simply alters its shape. It absorbs its surroundings and becomes something else without remorse. It is not cruel but it is without guilt or shame. The rhizome is not what it is but the multiplicity of its potential becomings. The frontier is merely the nature of its own self-unfolding. Some believe that this becoming makes the rhizomatic frontier a space of radical motion. In stark contrast to the sovereign and its frontier, the motion of the rhizome is "an acentered, nonhierarchical, nonsignifying system without a General and without an organizing memory or central automaton, defined solely by a circulation of states."[12]

But perhaps we should not rush too quickly past the amnesia of the rhizome—the fact that it doesn't remember where it started or where it is going. It just goes. This thing, this motion without memory or remorse, can suffocate what it encounters as systematically as the sovereign at the frontier—even other rhizomatic forms, motions, and dynamics. What in the concept of the rhizome keeps us from thinking of settler colonialism as rhizomatic? In 1492 a Protestant rhizome, cleaved from a fibrous unfolding Christian European bulb, floated to the Americas and began the process of its own reterritorializing. This settler rhizome happily threw off its previous form and declared its new becoming, a liberation from anything past, a new Jerusalem, a mode of sociality that was relentlessly everywhere

and anywhere, and without remorse. It dug in and changed the nature of the ecology. Like invasive ants it took advantage of scraps of food offered or left behind. Newtonian physics did not phase it. Every event of opposition provided an opportunity for a swarming. It surrounded what impeded it and declared the new form to be of its own making. What in the rhizome makes it one side or another in the endless game of espionage and counterespionage, insurgency and counterinsurgency? Nothing; it has no sides in the sense of a sovereign border. Hackers happily hitch a ride on mom and pop businesses, international corporations, or state agencies. The US National Security Agency turns to hackers to hack a terrorist's phone. The frontier is wherever an opportunity for movement is afforded.

Édouard Glissant long ago noted as much, distinguishing between forms of rhizomatic rooting. It is not rooting per se that presents the problem, but totalitarian rootings and the overdetermined conditions of nomadism:

> Take, for example, circular nomadism: each time a portion of the territory is exhausted, the group moves around. Its function is to ensure the survival of the group by means of this circularity. This is the nomadism practiced by populations that move from one part of the forest to another, by the Arawak communities who navigated from island to island in the Caribbean, by hired laborers in their pilgrimage from farm to farm, by circus people in their peregrinations from village to village, all of whom are driven by some specific need to move, in which daring or aggression play no part. Circular nomadism is a not-intolerant form of an impossible settlement.[13]

But "the Huns, for example, or the Conquistadors" perfected an "invading nomadism" whose goal was to "conquer lands by exterminating their occupants."[14] As if they were the advanced runners of a spreading plague from which they believe themselves to be immune, "conquerors are the moving, transient root of their people."[15] These followers would root down into the charred landscape, claiming it as property, fencing and commodifying it in a new form of conquest—the conquest of private cultivation.

Of course the conquerors were not immune. As Glissant's fellow Martinican Aimé Césaire wrote, the virus would soon turn and consume them, but not before much else of the world had been lost: "Each time a head is cut off or an eye put out in Vietnam and in France they accept the fact, each time a little girl is raped and in France they accept the fact, each time a Madagascan is tortured and in France they accept the fact, civilization acquires another dead weight, a universal regression takes place, a gangrene sets in, a center of infection begins to spread," and the poison seeps "into the veins of Europe" such that "slowly but surely, the continent proceeds toward *savagery*."[16] This savagery began and continues against forms of existence that are thrown over the other side of the frontier, thrown overboard as the privileged steam toward the horizon. These are overwhelmingly brown and Black bodies, the subaltern and the Indigenous, interned in the brackets of recognition. Thus it is not the sovereign or the rhizome that matter but the mode and purpose of the movement, the presuppositions about how forms of existence are related to each other, are fashioned from within each other. The goal is to not become a state in the face of an invading state. It is to not grab an anthropologist to act as your diplomat across ontological and cultural borders. Indeed,

diplomats create state-effects—they create the state they claim to be speaking on behalf of in global meetings. Pierre Clastres registered an ongoing refusal on the part of his interlocutors among the Guayaki in Paraguay to not become a state simply as a reaction to being confronted by a colonizing one.[17] Contemporary critical theorists like Audra Simpson, Glen Coulthard, and Aileen Moreton-Robinson have amplified a formation of human and nonhuman belonging that refuses the frontier options—to be a sovereign state against other sovereign states or to be the unruly frontier of a sovereign expansion.[18]

Across all of these works the question is not Newtonian or quantum physics, nor the confrontation between two equal or unequal forces, nor the unrooted movement of infelicitous unfoldings (nor of militant fidelity to specific movements or confrontations). The question is how Routes and Worlds and how extimate existences are enhanced or sacked by forms and imaginaries of movement. How does this thickened space come to force other regions to conform to its way of existing? What kinds of trailings, seedings, separations, and connections are left along the way as entire infrastructures pull stuff back and forth? How compacted is the material? What embankments are formed in the process? Where does the stuff of these embankments come from? What indentations are left behind? Europe did not predate the history of its multifaceted and violent dispossession of other modes of existence. Europe was not a value that spread or failed to spread its message globally. As W. E. B. Du Bois and Frantz Fanon argued, Europe, and by extension the US, Canada, New Zealand, Australia, Mexico, Brazil, Argentina, etc., built itself from externalizing its expansion into and onto the bodies of others. It ate

up and shat out others elsewhere than it claimed to be. The Congo was not in the Congo but in the shiny streets of Brussels; Congolese spirits haunt the streets of Europe, built as it is from their lands, bodies, and worlds. As Aileen Moreton-Robinson points to in her reading of Critical Indigenous Theory against Critical Race Theory and Whiteness Studies, the modality by which race was used to exterminate and dispossess actual native peoples provided one condition for another modality in which different Black and brown people were dispossessed of their bodies to labor for others. Thus a differential but shared relationship exists between the extractive machinery of Western privilege and the epistemologies and ontologies that legitimate this privilege. And it is within these spaces that a refusal to be either horizon or frontier continues.

All drawings by the author

1
Quoted in Fred Dallmayr, *Small Wonder: Global Power and Its Discontents* (Lanham, MD: Rowman & Littlefield, 2005), 185.

2
Jürgen Habermas, *Between Fact and Norm* (Cambridge, MA: MIT Press, 1996).

3
Christina Sharpe, *In the Wake: On Blackness and Being* (Durham, NC: Duke University Press, 2016). Édouard Glissant famously described this wake as consisting of three abysses that Africans faced as they entered the hull of the slave ship: the abyss of the belly of the boat itself, the abyss of the seas where many were cast overboard, and the abyss of memory as their traditions receded under the viciousness of removal. See Glissant, *The Poetics of Relation*, trans. Betsy White (Ann Arbor: University of Michigan Press, 1997).

4
Elizabeth A. Povinelli, *Economies of Abandonment* (Durham, NC: Duke University Press, 2011).

5
Elizabeth A. Povinelli, *The Cunning of Recognition* (Durham, NC: Duke University Press, 2002).

6
Mabo v. Queensland (No. 2), (1992).

7
Denise Ferreira da Silva, *Toward a Global Idea of Race* (Minneapolis: University of Minnesota Press, 2007).

8
See Elizabeth A. Povinelli, "After the Last Man: Images and Ethics of Becoming Otherwise," in this volume.

9
Martha Nussbaum, *Frontiers of Justice: Disability, Nationality, Species Membership* (Cambridge, MA: Belknap Press, 2007).

10
Gilles Deleuze and Félix Guattari, *A Thousand Plateaus: Capitalism and Schizophrenia*, trans. Brian Massumi (Minneapolis: University of Minnesota Press, 1987), 8.

11
Karen Barad, *Meeting the Universe Halfway: Quantum Physics and the Entanglement of Matter and Meaning* (Durham, NC: Duke University Press, 2007).

12
Deleuze and Guattari, *A Thousand Plateaus*, 19.

13
Glissant, *Poetics of Relation*, 12.

14
Ibid.

15
Ibid., 14.

16
Aimé Césaire, *Discourse on Colonialism*, trans. Joan Pinkham (New York: Monthly Review Press, 1972), 35–36.

17
Pierre Clastres, *Society Against the State: Essays in Political Anthropology*, trans. Robert Hurley (New York: Zone Books, 1989).

18
Aileen Moreton-Robinson, *The White Possessive: Property, Power, and Indigenous Sovereignty* (Minneapolis: University of Minnesota Press, 2015).

Time/Bank, Effort/Embankments

These short remarks emerge from a conference that two editors of *e-flux journal* organized at documenta 13 around the provocative assertion "I am my own money." Julieta Aranda and Anton Vidokle did not hide their investments. The panel was an extension of their globally situated Time/Bank, a tripartite arrangement consisting of a labor-exchange website, a series of conferences/panels, and curated exhibition spaces. At the center of Time/Bank is a working web-based skills-exchange network in which participants offer and earn "hour-dollar" credits for labor exchange. "Time banking is a tool by which a group of people can create an alternative economic model where they exchange their time and skills, rather than acquire goods and services through the use of money or any other state-backed value." But Time/Bank is not one thing. It is a series of forms of activity—a working labor-exchange network for the art community; an evolving concept about value, time, and labor in the context of art and global capital; and a series of exhibition spaces for insubordinate objects—meant to produce a form of life.

Rather than mere statement then, "I am my own money" is a demand and an assertion about something this is real and yet not actual. Time/Bank claims that the skills that I have, the skills that I am (my art, my thought, my affects and senses; my life as an exercise of my potential) *can be* the vehicle of not merely a new form of labor exchange but a new form of the social. What I already am could be the foundation for what is not yet. When we act on the fact that we are *already* our own money, we will no longer need the authorized currencies supporting what actually is. We will instead exchange the concrete forms of our specific capacities, and in doing so, change the actual world in which we live. I will directly invest in you, and you in me. I will give you

my capacity for perfect pitch; you will give me your ability to write software. Insofar as these kinds of capacity exchanges are oriented to an attentive other, the basic structuring category of social interdependence will be the specificity of my and your being and becoming in the world, rather than our measure against the illusion of an abstract coinage.

The tripartite activity-concept of Time/Bank and its assertion "I am my own money" stretches across two contemporary concepts of insubordination, if not insurrection—the concept of immaterial labor and the concept of the virtual—with the hope that these concepts could be concretized. But are these concepts adequate to capturing a certain kind of event, and certain conditions of the event, so as to create a counter-actualization (effectuation)?[1] In particular, how do these concepts help us understand something I have called "the tense of the quasi-event" (but that others have called "crisis ordinariness"[2] and "slow violence"[3]) and the conditions of the emergence and endurance of the otherwise? What would happen if we substituted the concept of Time/Bank with Effort/Embankments? The answers to these questions are not clear-cut.

For Negri and Hardt, immaterial labor refers to the *informationalization* of capital that came about when the service sector broke free of the service sector, reorganizing and resignifying the labor process as a whole. As a result, the service industry can no longer be thought as merely referring to low-wage burger and coffee shop employment or call center employees. The service industry now refers to an entire reorientation of labor, production, and consumption, including the financial sector, dependent as it is on information and communication technologies oriented to learning about and responding to the desires of others. This

information-communication network includes communication between software and machines and between commodities and market desires (other machines, other consumers, other producers). It doesn't matter what the concrete technology is. All sorts of technologies of information collection are deployed, including new algorithms that mine buying habits, paper slips distributed in hotels marked "give us feedback," and Facebook and Twitter feeds. What matters is the heart of this new logic of labor—affective-informational loops oriented toward capturing the desire of the other so that capital can insinuate itself ever more exactly, ever more anticipatorily, as the object of the desire of the other.[4] To be sure, service capital also seeks to anticipate what is real (virtual) rather than actual ("the next big thing"). But it does not seek to stage an antagonism of desire, out of which, the Hegelians posit, would come a world-historical unfolding that began with the master-slave and that would end with the universalization of equal recognition.[5] Capital seeks to anticipate our desire, not antagonize it.

But rather than viewing immaterial labor as the last locked door of the prison house of capital, Hardt and Negri see it as providing "the potential for a kind of spontaneous and elementary communism" within capital. This is for the simple reason that cooperation and mutually oriented affect, the hallmark qualities of elementary communism, are "completely immanent to the laboring activity" of immaterial labor, as opposed to previous forms of labor in which *coordination* with the activity of machinery was dominant.[6] Coordination might seem quite close to cooperation—coordination demands a high order of cooperation after all. But Hardt and Negri emphasize the difference between something

like the articulation of parts rather than a constant interrogation of others' wants and needs. "Be your own immaterial labor," they might say.

Deep within the DNA of Hardt and Negri's concept of immaterial labor as a potential insurrection within actually existing capital is their long conversation with Deleuze—Deleuze's influence on their thought; their worry that Deleuze did not fully conceptualize political subjectivity; Deleuze's worry that his ontology was being too quickly collapsed into a Marxist-Leninist framework.[7] Irrespective of these thoughts and worries, the way that the informationalization of labor and capital might provide a deterritorialization of capital without positing an outside to capital is clear. Service capital provides a cartographic line that is within the given assemblage of capital but which is also against what this assemblage presupposes and, in presupposing, attempts to keep in place. In other words, the cartography of an anti-capital immaterial labor is real—is really there in actual capital's immaterial labor—even if it is not yet actual. So, if it is true that this elementary communism is real if not actual, why not attempt to actualize this real? Create an event. Make a web exchange that orients artistic labor capacities outside abstract coinage; gather scholars and activists to think about this informationalized utopia; petition the art curators to mount the exhibit; move the exhibit from New York to Berlin to Kassel …

I am already exhausted. I say of my colleagues: I don't know how they do it; keep up, keep going; how they are able to do so many disparate things at such a high level at the same time and over such a long period of time. And then there are the parties.

This anticipatory exhaustion foregrounds what is in, but often not taken up in, the literature on counter-actualizing events, namely the effort of

emergence and the endurance of the otherwise. To understand what is at stake in thinking about the effort of emergence and the endurance of the otherwise, we can turn to William James, whom, as we know, Deleuze greatly admired. James proposed two still counterintuitive claims—namely, that mental concepts are forms of effort *and* the event is a fantasy. Let's start with mental concepts. According to James, the source of mental concepts would never be found by burrowing deeper into the mind in search of ever more abstract forms. Mental life is— and thus all mental concepts are—a cacophony of "efforts of attention." There are three results of conceptualizing the mental concept in this way. First, it demands we pay attention to the actual world in its vast multiplicity. Second, it demands we pay attention to the potential explanatory figurations (concepts) that might provide not so much an account of this world but an experiment in constituting it. And third, it demands we pay attention to where these constitutive figurations are able to emerge and why and whether or not they are able to endure the conditions of their emergence. For James, if we wish to find new truths, we will find them in the great energetic bustle, "the great mass of silently thinking and feeling men" and their myriad experiments in everyday life.[8] It is there where we will see how and why, or why not, initially murky sensations become ideas by a focused effort of attention that provides them with qualities and dimensions and then tests and toughens them in the very worlds from which they emerged. If we wish to understand why new truths wither or never quite emerge, it is because the same concrete social terrains that are creating and testing truth are also continually extinguishing potential worlds and thus potential truths in the quasi-events of everyday exhaustion.

Understanding mental concepts as a form of effort, James argued, demanded that we place mental life in the social worlds in which it exists—in which it is given dimensions and qualities, and spreads. In other words, mental concepts aren't merely situated in the social world. They are the social world as expressed mentally—and this is not the social world of meaning but the social world of distributed energies and abilities to focus on the task at hand. As a result, time itself is not something that can be presupposed any longer as empty, thus lending itself to a homogeneously smooth exchange (I will give you x hours of my capacity for y hours of someone else's). Who has the energy to focus, and when? I can give you four hours of canvas stretching but I keep getting distracted by my child crying in the other room. This is why all mental-physical capacities, as well as truth, must be understood to exist in the "open air" of the "unfinished world," rather than as the artificiality and pretense of a normative rule or an abstracted measure.[9] One can see Deleuze's interest in James here. No matter his ontological claims about the preeminence of difference over identity, Deleuze believes that the only place that difference exists is: in world as figurating force; the multiplicity of actual differences within these figurating forces; and the immanent lines that are real within them but not actual. And these figurating forces and their actual and real differences are not abstract or equal.

Thus rather than a Time/Bank, we might seek to establish an Effort/Embankment—some way of building modes of enhancing different regions of effort. The problem such an Effort/Embankment would face is the actual conditions of energy distribution—the kinds of "events" that account for the lack of effort of attention. Events of even the most

dramatic and self-evident sort are already constituted out of the dispersion of a multiplicity of quasi-events.

James makes this point clearly in observations on the 1906 San Francisco earthquake, published in *Youth's Companion* magazine. James notes that "the earthquake" was usually personified, often deified, even though in fact "earthquake" is "simply the collective *name* of all the cracks and shakings and disturbances that happen. They are the earthquake. But for me *the* earthquake was the cause of the disturbances."[10] Even the activity of shaking should not be given an identity: "the shakings" are an endless series of mutually composing relations, some still, some moving, some small—a fly's wing, a footprint—and some quite large—a highway, a molten flow. Moreover, all of these events are constantly occurring in and across every assemblage, even as each assemblage's abilities to persevere have already been reinforced or compromised. And this constant personification of a set of distributed quasi-events as morally personified force has a direct impact on our understanding of effort as an ethical failing or testimony. While acknowledging that we measure ourselves and others by many standards (strength, intelligence, wealth, good luck), James claims that "deeper than all such things, and able to suffice unto itself without them, is the sense of the amount of effort which we can put forth … the effort seems to belong to an altogether different realm, as if it were the substantive thing which we are, and those were but externals which we *carry*."[11] In other words, those for whom no effort has been invested are then held accountable for not having the conditions for making the right kind of effort—the kind of effort that would eventuate a kind of event: the new, amazing, world-transformative concept-activity.

How do we think about various explicitly aestheticized forms and genres of concept-activity that at once analyze and make worlds in which these efforts of attentive endurance are formed, thickened, and extended? And where and with whom?

1
See Gilles Deleuze, *Difference and Repetition*, trans. Paul Patton (New York: Columbia University Press, 1995).

2
Lauren Berlant, *Cruel Optimism* (Durham, NC: Duke University Press, 2011).

3
Rob Nixon, *Slow Violence and the Environmentalism of the Poor* (Cambridge, MA: Harvard University Press, 2013).

4
See Elizabeth A. Povinelli, "After the Last Man: Images and Ethics of Becoming Otherwise," in this volume.

5
See Elizabeth A. Povinelli, "Routes/Worlds," in this volume.

6
Michael Hardt and Antonio Negri, *Empire* (Cambridge, MA: Harvard University Press), 294.

7
See Michael Hardt, *Gilles Deleuze: An Apprenticeship in Philosophy* (Minneapolis: University of Minnesota Press, 1993). Nicholas Tampio has also argued that the "assemblage" is the political subject of Deleuze's virtual ontology. See Tampio, "Assemblages and the Multitude: Deleuze, Hardt, Negri, and the Postmodern Left," *European Journal of Political Theory* 8, no. 3 (June 2009): 383–400.

8
William James, "The Present Dilemma in Philosophy," in *Pragmatism* (New York: Dover, 1995), 29.

9
Ibid., 20.

10
William James, "On Some Mental Effects of the Earthquake," reprinted in James, *Memories and Studies* (Rockville, MD: Arc Manor, 2008), 88.

11
William James, "The Will to Believe," *The New World*, no. 5 (June 1896): 715.

In the Event of Precarity …
A Conversation
with Lauren Berlant

Elizabeth A. Povinelli I don't know about you, but my colleagues often remark on the deep conversational possibilities of our recent work, especially where my thinking about the endurance and exhaustion of alternative social projects through the quasi-event overlaps with your thinking about cruel optimism around non-event-like events. I am not surprised, of course. We began talking in Chicago almost a decade ago about the social and affective forms that characterize Late Liberalism. And it's probably not surprising that I would end up focusing more on what I would call energetic aspects, and you on feelings. I always err on the side of what I think about as the problem of the "endurant" and its social antonym, exhaustion and the problem of the tensile nature of substantialized power. Internal to the concept of endurance is the tense, substance, and eventfulness of Late Liberalism: the problem of strength, hardiness, callousness; continuity through space; an ability to suffer and persist. The endurant allows me to absent the question of feeling-affect. But that's what I love about your work. You don't.

Lauren Berlant A decade ago! More like fifteen years. In 1999 you stole the manuscript of "Love, a Queer Feeling" from my study and sent it to *Homosexuality and Psychoanalysis*.[1] (Thanks for that!) The previous year, we did a word-by-word edit of your "The State of Shame" for my *Critical Inquiry* special issue, "Intimacy." My computer tells me that in this same year we invented the concept of Late Liberalism for our working group at the University of Chicago, which grew out of conversations between you, me, and Candace Vogler about starting a project called "Monster Studies" (that was its nickname, from Jackie Stacey's *Teratologies*).[2] The aim of the project was to conceive of the world

beyond models of liberal intentionalist subjectivity and its refractions in a monocultural nation-state. That project eventuated in the conference we ran, "Violence and Redemption," which became a *Public Culture* special issue edited by Vogler and Patchen Markell.[3] (So it's funny and lovely to hear the return of the word "monster" in your current work on the Anthropocene: we can't get away from it, the staging of a tragicomic alterity.) Then, in 2007, you heard about my article "Slow Death" from Michael Warner, and wrote to me to get it for inclusion in what became your article "The Child in the Basement: States of Killing and Letting Die," and from there we entered phase two of our collaboration.

So it's not surprising to me that resonances are heard in our work: we've been working together, in and out of conversation, for a long time; many of your now thickly and beautifully developed rubrics emerge from those working-group days. What interests me so much is in your ever more explicit insistence on the ethnographic test for theory: what you, in your recent keynote at an Anthropocene conference, called a toggle between "on the table" and "on the ground," as in: "when immanent critique occupies the world it claims its own ground." I would love to hear you talk about that test—what constitutes the ground, what it means for you to say that, especially since you also, unlike many anthropologists, also mobilize the aesthetic.

But to get to your framing question. You and I share, for sure, an interest in "the endurant" and the exhausted: "Slow Death" was the first place I worked it out, but I'd long talked about politics as a war of attrition, riffing off Gramsci's "war of position" and "war of maneuver" as well as his keen sense of how hypervigilance and compulsive strategizing can wear a body out. Even in your first book, your

interest in exhaustion emerged from structural and symbolic notions of economy that crossed the structural and collective sensual life.

But we're both also interested in how the ongoingness of life produces an *energetics* of endurance—through touch, proximity, and conversation that's both narrative (against the state and for the collectivity's self-adherence) and eruptive in particular moments of pleasure. I hadn't thought that our difference was a difference between a practice-based tracking and an affect-based one, though, since I am also compelled by how people live and spend a lot of time tracking practices of the reproduction of life from within life. Of course, I have to rely on other people's ethnographies for that, while also tracking their intensification and refinement as pattern in aesthetic mediations.

But you're right, I'm interested in the affectivity of disturbance, the reproductive and inventive labor of the unsaids and atmospheres, the moods and repetitions that exist without being congealed into normative forms. Maybe it's that you are more likely to track feedback loops of response and effect, and I am more likely to sit inside of the moment of disturbance before form provides an anchor? You are more likely to seek to capture a structure (of knowledge, power, expertise) in any of the exempla you offer, is that right?

EP Yes, I think the concept of a feedback loop is a nice way of imaging what interests me, but with the caveat that the loop doesn't loop so much as leak because of the superabundant varieties and variants of feedback crowding in the same space. A superabundance of the supervalent—to give a nod to the name of your blog where you define "supervalent" as a concept that generates all kinds

of contradictions—can be magnified to induce an impact beyond what's explicit or what's normative.[4] Like Althusser's concept of relative autonomy on crack: the feedbacks are far more than can be descriptively or experientially accounted for, in part because they include all the potentialities expressed by an actual feedback loop.

Leaving aside this caveat, I am indeed drawn, compelled perhaps, by aesthetic and argumentative artifacts that live at the precipice of the figured (normative, anti-normative forms); the fog of becoming; something that might be something if the conditions of experiencing it or the conditions of supporting it are in place. And I am equally drawn to aesthetics and arguments that put two given figurations in play but then pause at the potentialities welling up at the moment they touch. In my own writing—and filmmaking and drawing—I struggle to convey the superabundance of feedback without quickly leaping over the moment before the fogs of becoming become dominant, or the moment before minority figures have clearly marked out the justice of their terrain.

This is why I have consistently thought with and within your writing. Of course, crawling around the interior of someone's mind for such a long time—fifteen years—makes memory a meandering loop. I don't remember making off with "Love, A Queer Feeling"; you're so generous with your writing, I doubt I would have done so except for some perverse pleasure. But I was not the least surprised when we both wound up at a Pembroke Center conference in March 2004 and you were working on [the chapter] "Two Girls, Fat and Thin" for *Cruel Optimism* and I was working through [the chapter] "Rotten Worlds" for *Empire of Love*.

What I do remember are much earlier conversations we had around drafts of "Sex in Public,"

[the essay you cowrote with Michael Warner]. I have always especially been drawn to the example that closes the essay. For anyone who hasn't read this essay, it describes a performance at a now closed sex club in New York:

> A boy, twentyish, very skateboard, comes on the low stage at one end of the bar, wearing lycra shorts and a dog collar. He sits loosely in a restraining chair. His partner comes out and tilts the bottom's head up to the ceiling, stretching out his throat. Behind them is an array of foods. The top begins pouring milk down the boy's throat, then food, then more milk. It spills over, down his chest and onto the floor. A dynamic is established between them in which they carefully keep at the threshold of gagging. The bottom struggles to keep taking in more than he really can. The top is careful to give him just enough to stretch his capacities.

The cum shot eventually happens. And then a series of questions you wish you could have asked the young bottom who was, so rumor went, straight, including: What does "straight" mean in such a context? How did he discover that this is the form of public intimacy he wished to share? How did he find someone to do this with him? I love these questions, and of course think you were right that this was citing the money shot in porn. But when we talked about this essay, and when I teach it, I am drawn to all the things this performance was and might become—and in so doing, the way this performance might potentialize minoritization. What if the vomiting wasn't already a figure of the sex and sexuality we know, but an insistence that sex could be a minor form and drama of spitting? What might be

the forces that would allow this virtual other body to emerge and endure?

I think that's why I don't use the term "structure"—the capture of "structure"—and why I am trying to see what kind of conceptual work effort, embankment, and quasi-event can do rather than return to the discussions around structure and event, which, as you know, lead us to interesting but somewhat exhausted arguments. Your work on the labor of the uncongealed economies of unsaids, on dynamic and flat moods, on stifling and overrich atmospheres, is anathema or an antinomy to the overly semanticized approach to structure and event or structure and praxis. So I always start hyperventilating when I hear that I am interested in structure. And why, beginning maybe most explicitly in *Empire of Love*, I began to try to think about the enfleshed aspect of the fog of meaning and its coming into view. This is what I am exploring with the idea of an embankment rather than a bank of meaning and bodies and all the minor and quasi-events that hold these embankments in place.

And it's what I love about [Charles Burnett's 1977 film] *Killer of Sheep*, which is really what I was hoping we could think with and through.

LB What questions remain for you in particular—you've worked with that text exhaustively, no?

EP Well, yes, that was lazy of me. I put *Killer of Sheep* to use in *Economies of Abandonment*, but in a fairly crude way, picking out the parts, and what I saw as a strategy of the whole, to exemplify the cinema of the non-event. But in *Cruel Optimism*, you talk about the cinema of precarity, yes? And I find that very, very intriguing, especially as my very old friends in Australia and I are drawn into making a

series of films about the conditions of agency and geography that characterize their ordinary lives under the auspices of the Karrabing Film Collective. I continually come back to our "Monster Studies" and your thinking around the aesthetics of precarity, and your thinking about film and media more generally. For me, this new endeavor forces me to think from two different but braided perspectives. On the one hand are questions that are text-internal or film-as-text: How to develop a compelling narrative form that breaks with presuppositions about the nature of the event? How to narrate the endurance outside liberal heroic tropes of the overcoming of all odds? What are the range of affects that typically track with the endurant and support what you call the forms of cruel optimism, and why?

On the other hand are questions external to the film-as-text. That is, the film from the point of view of its emergence: the group that scripts it, casts it, situates it in a specific location and then acts it out. And this is especially intriguing when, as in *Killer of Sheep*, or among the Karrabing Film Collective, the lives that are being acted out track the lives people are living. The conditions of life in which my friends find themselves radically attenuate agency—they "flatten people's batteries," in the local idiom. So the activity of formation, the activity of producing a life from within their own life, is a significant event-experience. It is also a mode of critique, since, as we script and cast and plot and act/direct, we ask, why this plot, why so-and-so in this role, why these events? What part of the narrative is likely to happen in our everyday lives—and what is unlikely, surprising? And this is also an event happening from inside the activity of filmmaking. Of course, there's no separating these insides and outside—their extimate relationship is clearly

evidenced when it comes to moving the filmic effect of all this into an editing room and then across the various platforms of viewership.

So, I was wondering how your thinking about the cinema of precarity would apprehend *Killer of Sheep* as not merely my crude way of taking bits and pieces of a film and using it as exemplary of a reading of a formation of power and possibility, but as part of the cinema of precarity in a fuller sense—how different kinds of practices of self-scripting don't merely represent the cinema of precarity, but also provide an embankment around the energy it takes to endure the conditions of precarity.

Or, how do you think about the makings you make on your blog?

LB This morning on the way to the gym, I had a conversation with a friend about an ethnography of contemporary pleasure economies in which everyone tries to plan out an event that will be invariably disturbed by experience. We talked about the concept of "the bucket list," with its desire that life should entail experiences that make monumental memories that one can know in advance and predict, but that still demand the risk of an immersion whose frisson induces delight in the sense that one has really lived. Tonight, I went to get new glasses and got buyer's remorse, but they don't let you return your own face. Then I went to dinner, and although it was vegan and organic, it made me itch. Then I went for a walk, and although it was night, it got warmer and warmer. There were others in all of these situations, and a lot of warm noise. I checked my phone a lot, and answered email in the interstices such action makes. By the time I reached home, it was too hot to bear my cat sitting on my lap while I was reading a Gayatri Spivak piece. It was a good day, but

I had a hard time maintaining my good humor in the middle of the sheer energy of sustaining all of the relations I encountered and imagined, the work of holding up the world—not feeling alone in it, exactly, but never quite knowing who the other was in relation to the sustaining project of mutuality. I could not make the cat leave. But I cast him as a friend with whom I pass warmth back and forth.

Some forms of relation feel simple even though they are unbearable, unscripted, and at some level unnecessary, except in every way. Other relations are organized by the embrace of the competitive, the aggressive, the prematurely disappointed, and assurance about who's the victim and who's the unjust threat. Other ones proceed through sheer will, without much reflection on their cost. Others are convenient, conventional, and not forgettable, but easy to file away. Your films, like *Killer of Sheep*, are fantastic documents of the relation between antagonism and jostling in the episode and solidarity within a creative and world-extensive structure. The kind of movement one makes to keep some things open and to deflate and shift the shape of the others is something like what you call the "embankment" around ordinary precarity.

The queer, the psychoanalytic, the ethnographic, the historicist relation to the event understands its relation to temporality to be not at all constituted by an immediate impact, but by what Shaka McGlotten calls the sensual "bleed," mediated through practices of life-making and projection.[5] This attitude grounds what engages us both: a skepticism, in the philosophical sense, that leads to attention to the bleed and the shape of the scar that keeps changing, fading, and becoming prominent over time, and reopening. Patterns emerge and converge and something is induced through

their infrastructural mediation of the world to itself. Where we part a bit, I think, is on the question of the event. I prefer to say the "becoming-event" of an impact or situation rather than the "quasi-event," because your phrase still signals to me an anchoring in the self-evidence of impact. I always prefer to dial back the sense that a determining action has occurred—seeing impact as more like a prompt—and track its appearance as circulation, transformation, and mediations—what I boringly call its way of "finding its genre." From this perspective, precarity is ontological, the openness of the world to the relation among its structures and emerging patterns, our heuristic habitation of it all, and the forced openness we have to each other's tenderness, historical trail, and need for things to go as well as we want (where desire meets aggression). Again, that could be a caption for your films, or *Killer of Sheep*.

But the cinema of precarity is also specific and materialist. It is all about what resources remain for generating life beyond the minima of survival; it is about the costly demand on precarious individuals and populations to practice affective and economic austerity. In the precarious aesthetic, docility, exhaustion, and the minor pleasures are revealed to be ways out of defeat, modes of stuckness, and what needs destruction. *Who* the precarious are is less objective than it sometimes seems, nonetheless: there are so many different kinds of structure involved with precarity's fact and atmosphere. *Killer of Sheep* is an amazing demonstration of this: of the fragility among intimates, of being on the make as a way of refusing to be the sheep that one is killing, of understanding that violence and death are parts of the ordinary, are low-level attritions within it that also provide uneven kinds of nutrition. And then there is the

precariousness of time for thought, of the capacity to experiment in life, of love. Those long, quiet shots. The importance of children playing without a plot, and improvising effects. The film asks the question: Which is worse, a fully developed consciousness, or the modes of dissociation that reduce suffering and allow for the expression of complex, contradictory, and counterintuitive motives and practices? I think the latter wins in the film: a consciousness from a biopolitical perspective that takes in everything and holds it in presence as a resource for living lives also with the threat of an affective collapse (see Fanon and Patricia Williams for more of *that*).[6]

So what I point to in the cinema of precarity is the operation of a structural state: a motile membrane of consistency absorbing many locales and lives into its logic—not the drama of antithesis to the affecto-practical place where intuitions are made from the visceral disturbances we share, but a structure of feeling like what you call fog. What an event is isn't the opposite, a non-event, but rather a developing scene in which *we pay attention* to what takes shape from within the disturbances of relationality. I worry about the language of the minor the way you worry about "structure"—it points so much to a reduced version of its opposite. But I guess in that sense we are both occupying and redistorting concepts that ought to be richer and inconvenient to the desire for efficient description.

Sometimes within spaces of poverty, people's pleasure in reproducing life allows suffering to pass through time and action like the momentarily good and aversive smells one walks through all day. Desperation is a taxing noise that gets more or less intense. Sometimes in the places of economic cushion, emotional austerity is the norm for virtue, and waste makes ordinary action toxic and the

atmosphere cortisol-cranky. I always try to remember that what we call the structural reproduction of life is about the relation of concentrations of wealth to other forms of social value and not just of who has the money. Your films show that pretty wonderfully. People wander, make music, put off the state and the law, have conversations, are quiet, eat, hang together even when they're separate, tell stories, try to make sense of things in a way that will get them a mode of living they can look forward to reproducing.

At the same time, so much of their creativity is bound up by fighting for a place in and outside of the state, and it is *this* drama, the binding of social energy to reproduce the bad life, that gets me and is the basis for what I gather into the domain of precarity aesthetics. So much amazing life energy is bound up in our own affective, bodily, imaginative, and practical poisoning for life. I feel that when facing the convenient stranglings of heteronormativity, white supremacy, colonial nationalisms; the ratcheting up of all of those toxic magnets amid the global elite's project of biopolitical shaming and release from liberal citizenship's already thin norms has now added new logics to the double binding.

What we have always seen together is the rich resource in relationality, richer than family and hoarded money. We have always seen together that the worst suffering and the most unbearable precarity is in the radical individuality sold as liberal freedom, where people imagine that competition is what's natural while relations that build worlds are exceptional, like dessert. We also reject the version of the family that stages as love the subordination of children to the parental fantasy that here, finally, sovereignty can organize everyday life. Who needs it? Well, lots of people think they do because that's how they learned love and learned to imagine

belonging. Anarchists like Proudhon point out that it's cooperation that one can't live without, while competition is what threatens living.

You write that "the conditions of life in which my friends find themselves radically attenuate agency—they 'flatten people's batteries,' in the local idiom." But it is also true that batteries are flattened wherever the reproduction of life captures all of the creative energy of life, which is most places, no? Is that why you turn to art? Is that why you make figures to map transfers across time and space? Is that why you think of role-casting as counter-precarious? Why you keep writing? Because these modes unbind attachment, make counter-histories possible, and affirm effort?

EP Yes, I think their metaphor of subjectivity as a flattened battery is quite extendable—their analysis of the problem of maintaining a relation to life, place, each other, worlding should not be understood as a local cultural idiom in the anthropological sense, but as a theory, a rapacious analysis of the conditions of Late Liberalism as they land in places like Indigenous Australia. "Like in ... " is of course more of a deflection of the problem than an answer to the question of what constitutes comparison, equivalence. In *Economies of Abandonment*, I discussed a washing machine lid that flew off the back of a rented truck as a group of us moved from a form of homelessness to a state regime of public housing. I used this as an example of the kinds of events that create the kinds of catastrophes that the state and the public tear their collective hair out over. How do we coordinate the snapping of a shoelace with the stubborn disadvantage of Indigenous social worlding? I also note that quasi-events are the general condition of all human social life. My

shoestrings snap all the time. What my Indigenous colleagues are noting with the metaphor of the flat battery is the fact that quasi-events have a different kind of force depending on where they occur in the socially distributed world. The effort it takes to undo, reverse, move on from the trivia of derangements in their lives verses mine is not trivial. And here, that amazing rendition of the effort involved in procuring and then losing a motor engine in *Killer of Sheep* will never cease to haunt me. My colleagues insist that I understand that the effort it takes to recharge a battery in a context in which everywhere and everything is deranged is of a different order than recharging a battery where this is not the case. So the entire world might appear to consist of the same type of quasi-events, but because neither the event nor the quasi-event are transcendent to their immanent and actual conditions, what appears as a quasi-event in my New York world and what appears as a quasi-event in their, and their-and-my, Karrabing world, are not equivalent.

Maybe the phrasing "becoming-event" would help point to the way that forms of eventfulness can seem comparable across socially differentiated substance-space even as they are not of the same type or mode. But I think the phrase "becoming-event" actually points to the moment that obsessively compels us both, maybe; that is—and I don't have any powerful or beautiful language to describe this, alas—how and why and the moment when peopled places gather whatever creative energies they have left to derange and arrange these kinds of flattening nothings into charging somethings. After all, as we both know intimately and theoretically, the transformation of nothing into something is a miracle as much as a manner of being. It was you who first said to me that the

difference between zero and one is larger than any sum between one and infinity. And this difference is the difference that my Karrabing colleagues face. And thus, thinking about the cinema of precarity as a resource for generating life beyond the minima of survival is rich, crucial, and important.

And now I am going to say something truly sentimental and banal. Buddha supposedly said that there are many roads to enlightenment. But of course this is true only if we remember that the reason there is not *one* road to enlightenment is not because there are many roads to enlightenment, but because each way of approaching a problem reveals that the problem was not one problem in the first place. And this is indeed why I love thinking with you, whether, as in this case, our thinking together is via a Google document read and responded to across cafés, home offices, bush camps, or gyms, or whether our thinking happens via thumbed-through books and my pork fat and your veggie burgers in the interstices of talks and conferences. My road is never exactly your road, and so where we stand in the end is a shared place, an opening, but not a Heideggerian open. Ours is weirder, warped, shared but not the same. What could be better?

Lauren Berlant (1957–2021) taught English at the University of Chicago. Their books include *Cruel Optimism* (2011), *Desire/Love* (2012), and, with Lee Edelman, *Sex, or the Unbearable* (2014). They also edited a few books on affect and emotion—including *Intimacy* (2000) and *Compassion* (2003)—and served as coeditor of *Critical Inquiry* and series editor of TheoryQ (Duke University Press) with Lee Edelman. They blogged at *Supervalent Thought*.

1
Tim Dean and Christopher Lane, eds., *Homosexuality and Psychoanalysis* (Chicago: University of Chicago Press, 2001).

2
Jackie Stacey, *Teratologies: A Cultural Study of Cancer* (New York: Routledge, 1997).

3
"Violence and Redemption," ed. Candace Vogler and Patchen Markell, special issue, *Public Culture* 15, no. 1 (2003).

4
Lauren Berlant's blog is called *Supervalent Thought*.

5
Shaka McGlotten, "Ordinary Intersections: Speculations on Difference, Justice, and Utopia in Black Queer Life," *Transforming Anthropology* 20, no. 1 (2012): 45–66.

6
In particular, Patricia Williams, *The Alchemy of Race and Rights* (Cambridge, MA: Harvard University Press, 1991); and Frantz Fanon, *Black Skin, White Masks*, trans. Charles Lam Markmann (London: Pluto Press, 1986 [1952]).

After a Screening of *When the Dogs Talked* at Columbia University with Audra Simpson and Liza Johnson

Audra Simpson Where was *When the Dogs Talked* made?[1] And why was it made? How does it relate to the earlier short film by the Karrabing Film Collective, *Karrabing: Low Tide Turning*?

Elizabeth A. Povinelli These film projects began as something quite different from what they ended up being. I talked a little about this in an earlier *e-flux journal* essay. A very old group of friends and colleagues of mine were working on a digital archive project that would be based in the community where they were living. But after a communal riot, they decided being homeless was safer than staying in the community. So what began as a digital archive that would be located on a computer in a building in a community was reconceptualized as a "living archive" in which media files would be geotagged in such a way that they could be played on any GPS-enabled smart device, but only proximate to the physical site the media file was referring to. We thought this augmented-reality-based media project would have two main interfaces, one for their family and one for tourists. And they thought this would be a way of supporting their specific geontology—their way of thinking about land and being—and create a green-based business to support their families.

But they faced two obstacles as they tried to build this living library. On the one hand, the Australian economy was increasingly oriented around a mining boom, supplying raw minerals to China. This raised the value of the Australian dollar and the price of goods and services, and crippled other domestic industries such as software design and tourism. On the other hand, a sex panic was gripping the nation around the supposed rampant sexual abuse of Aboriginal children in remote communities. The federal government used the sex

panic to roll back Indigenous land rights and social welfare, and to attack the value of Indigenous lifeworlds more generally. So instead of making the augmented reality project, my colleagues decided that we should make a film that tries to represent and analyze the conditions in which they were working—the small, cumulative events that enable and disable their lives. They thought this would give everyone a sense of the various kinds of media objects that could eventually be in their geontological library. And I should say that they wanted to make a film with people who could show them how films such as *Ten Canoes* (2006) were made. That is, they had a very specific kind of film in mind, one that, at least initially, demanded a level of craft that I didn't have.

I asked Liza if she'd come out, meet the Karrabing, workshop the story with us as a collective, and codirect our first film, *Karrabing: Low Tide Turning* (2012). I had seen and heard about a number of short films she had made, especially *South of Ten* (2006) and *In the Air* (2009), and I thought she'd be perfect for what we wanted to do. *South of Ten*, for instance, is able to pay cinematographic attention to the ordinary material conditions of getting by in the wake of Hurricane Katrina without making them a weird dramatic personage. In one clip you see a woman washing dishes in a large white bucket with a FEMA trailer in the background. The heat, the industrial nature of the bucket, the FEMA trailer—these are the completely non-remarkable conditions of the cast-off and getting-by. *In the Air* also got my attention for similar reasons. It's set in the crumbling US rust belt, now the meth belt, and encounters a group of kids who have set up a circus school as a way of organizing a center for their lives. For me this film is a study of the small, nonspectacular

ways people try to create projects and events that can sustain them in the midst of social and material decay. Oh, and I should say that both films work with nonprofessional actors.

Liza Johnson Of course I knew Beth, and Beth's work, when she invited me to do this project. I was interested to meet her friends and family. I was also interested in the intellectual intersections of the project because it seemed like a compelling opportunity to work across the discourses of art, cinema, and anthropology, which have a lot to say to one another but often fail to say it. I hope and believe that this is changing, but for a long time I have felt the very strong legacy of modernism in art contexts, a legacy that can be suspicious of documentary impulses and ethnographic research, as if these methods are dangerously unmediated, or somehow claiming to be "in reality, in truth, not in ideology."[2]

And then on the flip side, in anthropology, it can seem as if *only* ethnography is real, and that there is no thinking done by representation—that filmmaking is just craft knowledge. I had collaborated with an anthropologist in the past, and when we finished the project he was very quick to claim mastery over the content, relegating me to the form side of the equation, as if the two could be easily separated. And as if you can have mastery over content when that content is itself a group of living people who have mastery over themselves!

Within art contexts, this split sometimes has formal implications too, most obviously between a representational paradigm that may aim to generate shifts in meaning or ideology and a public art or relational aesthetics paradigm that may think of social relationships as the material and medium of the work. But isn't it possible to gesture in both directions?

Cinema and theater offer a lot of models that we could aspire toward, including: Augusto Boal's Theater of the Oppressed; the kinds of participatory projects that Jean Rouch made and that Faye Ginsberg champions; classical and contemporary forms of neorealism; and even in the legacies of minimalism, like Akerman and Warhol, for the ways that eventfulness and the everyday are distributed. I've been very interested in Lauren Berlant's project, including her characterization of the cinema of precarity, and in Ivonne Margulies's work on realism, and especially on the role of description in creating a kind of critical purchase on eventfulness. These references, in conversation with a set of references traditional to the Karrabing mob, were the basis of the workshop that we did with the Karrabing. Fundamentally we aspired to Boal: What are the conflicts of everyday life, and how might we act upon those conflicts if we try to act them out?

EP *Karrabing*, *When the Dogs Talked*, and the film we're currently making, *The Waves*, are interesting hybrids, mixing Boalian and Karrabing analytical techniques, neorealism and collective ethnography, representation and enactment of social worlds. But the Karrabing is also an interesting hybrid, maybe deranged, social form. The Karrabing is not a "tribal group" nor a place. Karrabing is an ecological condition—it's the Emmiyengal word for the state when the tide has reached its lowest. Most members are from contiguous coastal regions around the Anson Bay, though from different so-called traditional lands. So the Karrabing decided to use this ecological condition as the name of its legal corporation in order to emphasize that they are a kin/friendship group rather than a local descent group, namely, the kind of social formation the state recognizes as a

form of land-based ownership and decision-making. So making films that represent and analyze the conditions in which they are living is also what allows the Karrabing to make a case that the kind of social form they are should create a space in state forms of recognition—especially the domineering classical anthropological imaginary of territorially based clans and tribes.

AS *Dogs* seems at heart to be a critical analysis operating outside academic genres of explication. On the surface we seem to be watching a fairly straightforward plot. *Low Tide Turning* told the story of an extended Indigenous family who, faced with losing their public housing if they don't find a missing relative, embark on a journey to find her, only to wind up stranded out in the bush. *When the Dogs Talked* incorporates this plotline but seeks to tell a slightly different story: "As their parents argue about whether to save their government housing or their sacred landscape, a group of young Indigenous kids struggle to decide how the Dreaming makes sense in their contemporary lives." But the film stages, without being stagy, a clash between various kinds of authorities over the meaning and sense of what gets glossed in various literatures as "the Dreaming": the ancestral world of beings who made the present geography.

On the one hand, the film is slung around the continuing presence of a Dog Dreaming—a group of dogs who once walked and talked like humans. As the Dogs traveled along, as they tried to make a fire and eat the yams, they rubbed their fingers down until they turned into paws and burnt their tongues. So today, dogs can no longer speak. Each place where they were frustrated, they made a mark on the land. So the film shows, for instance, a set of water

wells that the Dogs made as they tried to make a fire. These Dreamings do much more than mark the movement from territory to place. They connect people to that place and to each other through time. These Dreamings carry with them boundaries in their stories and in their telling of the story at places.

But even here the state has another "dreaming," and this "dreaming" would be the legal and public fantasy about what a traditional group should look and act like, how it should be composed, what people are allowed to think and say about their "traditions." This is what you're referring to when you say that the Karrabing do not conform to state-based modes of recognition. And we see this in Canada too, after the Van der Peet decision—and maybe less virulently in New Zealand. We could say that the state has a dreaming of the Dreaming: a form that Indigenous and Native peoples must conform to in order to be traditional in the right way, the state way, to get back your pre-settlement rights to your land, *no matter that these state-ways are not your ways*. And throughout the Native world we see lives lived in a constant contortion, and it's not a good yoga pose. It's collectively experienced and carries great costs.

I love that the film pivots this analytic around a young Indigenous girl, Telish, and what *she* believes made the water wells—ancestral dogs who walked and talked like people? Or a human machine of some sort? Telish is being told the story of her mother's dreaming and thus her mother's land and her mother's law, what I think we might understand as law. Does she believe this, does she think it was dogs that do this or did this, or does she think the machines did this? This is the invitation I think: to sit with Telish and wonder what to think. Because settler and Indigenous dreamings are operating in the

same place among the same people, and it leaves in the center of the narrative a space for doubt or skepticism. Which should I believe? Is this state or this dog story really real, is this really true, should I believe this? This space of internal skepticism about both is very generative and productive, but so subtly played. At the beginning of the film, I saw the shadow of doubt on her face. And then at the end of the film, I saw no doubt, I saw a belief, and then I saw fear.

EP I am glad you liked that. We wanted to dramatize that the materiality and sociality of the dreamings exists here and now and thus must continually find some anchor in the actual world people live in if they are to continue existing. So the pivot of the movie is about the kids asking themselves: If we agree that the world is literally, ontologically formed one way or the other, what does that make us retrospectively? If we agree that a huge dog that walked and talked like humans made the geography, what will we be? Primitives? Uncool? Backwards? Hicks? So the film is cut to use Telish as the person who is considering this problem. If I believe and act on the belief that dogs made these holes, does this put me in an impossible space, put me in a space between the state, pop culture, and my love for my family?

AS And I think this is why there's always been ethnographic austerity in your written work, Beth—in what you write about your friends and colleagues. I'm seeing this now in this film. There's a politics in this descriptive austerity—we're shown the richness of the ways in which these people are communicating; the way they make boundaries; and what lies beyond boundaries and then simultaneous orderings, as well as the continued life on land with others. But the analysis is focused on the ways that the ordinary

everyday workings of state bureaucracy and poverty drain the resources and energy from them—and how they nevertheless keep going along.

And here is where I see another kind of dreaming authority, white man's dreaming, by which I mean the state's dreaming, its architecture, its bureaucracy, and its regulations, its "standards of cleanliness" and ideas about safety. In *Dogs*, we see and feel the effects of this imagining or coming-into-being of the settler world as it re-instantiates itself over and over again in Indigenous life through its techniques of surveillance, regulation, and the production of poverty—the overcrowding in government housing, for instance, because they have made living in rural and remote communities almost impossible.

I say "the production of poverty" because you can see so clearly at one point the profound desire and exasperation that comes with this desire and call to hunt. This call and desire to hunt needs to be set aside to chase Gigi so that she can show up at territory housing, and I guess rather ridiculously, make a case for herself in terms that such a state will understand. Which is probably not the excuse that it probably is, which is simply, she's being a responsible family member while living in Darwin. In terms of Indigenous life-worlds in what are called multicultural liberal settler colonies or former colonies, there's a terrific press for performance. It's the performance of pure culture, it's the performance of not having lost what you were actually supposed to lose quite fast.

EP Yes, this is exactly what the Karrabing want to get on the table—or the screen. How both of these positions—"I believe that dogs once walked and talked like we do and that they made water wells that still exist"; "I don't believe ..."—constitute an impossible choice thrust upon them. And what kinds

of efforts allow them to live the answer rather than answer the question. What I mean by this is fairly simple-minded. In making the film, in staging the kids having an argument about what might have made the water wells, the Karrabing are in fact keeping the water wells and the Dog Dreaming alive and active in their kids' minds.

AS Do you care about the genre of this film? It doesn't seem to be ethnographic, it's not documentary, but the narrative is, if I am right, lifted out of the actual lives of the Karrabing. So there's that kind of slyness of genre in this performance. At what point does performance begin in that kind of dialogic space?

LJ In this particular social context (and arguably in others) there isn't really an outside to performance. When we undertook this project, the question was intensified by the federal intervention—the rollback of Indigenous rights based on a sex panic. Prior to that moment, to secure resources from the state, it was necessary to perform your (real) relationship to tradition to get control over your land. And then suddenly, on a dime, to secure resources from the state, you have to perform your relationship to assimilation.

And so that conflict, while not articulated in those terms at every moment of everyday life, does place performance demands on subjects within their social worlds. And it also bears on the representational question within the film. I like how Audra is talking about how that is intensified in the figure of Telish, and I think a version of the same is also true for the other characters.

It raises a question about performance, one that can also be raised in other kinds of neorealism. This question has to do with what happens

when there are "breaks" in performance. Do those breaks function in a Brechtian way, offering a critical distance of some kind? Or are they really even breaks, since the performing subject is *also* asked to perform in certain ways outside the framework of the film performance?

The story is designed collectively through a kind of workshop process. But as for the script, I don't think there is one. Improvisation, which in all its forms—comedy, jazz, acting—really only works when you're working off of a structure, is a really useful technique when working with nonprofessional actors. Through workshopping, everyone knows what's going to happen and knows what the scene is and knows what they're trying to do, but gets to say whatever they think is the right thing to say.

This is where it's also not just representational, but an enactment on the ground in a particular context. It's a very contingent world, which has a determining impact on the narrative decisions. But on the other hand, there is no way to overstate the ways that the obstacles of poverty and racism can limit people's ability to do the things they want to do, and so we all had to ask ourselves, how much of a continuous story do we want to try to tell when it's completely unclear whether the people who can appear on day one of the shoot will be structurally able to return for the second day? And in that sense, it's radically different from industrial filmmaking, where that's all guaranteed and bonded by an insurance company.

Which actually was an interesting enactment while shooting because—and I mean this in a very non-self-congratulatory way, and I am suspicious of people who would congratulate me or Beth on this topic. But there is a real scarcity of meaningful work, or any kind of work. And on the days when we

were working, there was, and that was an interesting enactment in the space—a day of meaningful work, though sometimes boring, is a different day than a day of no work. It's one of the relational things that is changed during the shooting.

EP Yes. For a while I was assigned the job of directing. Part of my job was allowing for constant potential rearrangements of character, dialogue, and story line. In our recent shooting of *The Waves*, for instance, one of the young men, Cameron, did not want to be cast as a member of the group of young men who stumble upon two cartons of beer. He wanted to be a Karrabing Land Ranger instead. His change of mind came fairly far into the story design, but because everyone thought this made sense for Cameron, my job was to help realign the story—and it didn't have to work out this way, but it turned and deepened the story as we incorporated this new character.

AS What has the film done? Both of you have said it was as much about constituting Karrabing as representing them.

EP Yes, that's right. Of course, one of the central questions is how does one shape the force, form, and direction of this constitution so that one can take advantage of certain, say, Late Liberal/neoliberal discourses of capacitation, even as what is being capacitated does not conform to the imaginaries of difference and markets within Late Liberal settler society.

LJ I'm suspicious of certain new and powerful models, which are increasingly being used by documentary funders, of requiring documentaries to

have "measurable impact." (Meg McLagan's work on this topic is extremely useful.) I think it's our job as artists and intellectuals to be out in front of things, like canaries in mine shafts, and to be looking for things which are there to be sensed—like a tingling and hopefully collective spidey-sense—but which might not yet be there to be measured. Something more like "structures of feeling," or things that are in the air, which might have some other kind of impact, some immeasurable impact. Part of what we're doing is asking, collectively, what would be our categories?

EP I think this is the perfect place to end.

Liza Johnson is the writer and director of the feature film *Return* (2011) and the director of *Hateship Loveship* (2013). She has also made many short films and installation projects that have been exhibited in festivals, galleries, and museums internationally. Her short films include *South of Ten* (2006), *In the Air* (2009), and *Karrabing: Low Tide Turning* (2012). Johnson is also the author of many articles about art and film, and is professor of art at Williams College, Williamstown, MA.

Audra Simpson is associate professor of anthropology at Columbia University. She is the author of *Mohawk Interruptus: Political Life Across the Borders of Settler States* (Duke University Press, 2014). She is the editor of the Syracuse University's reprint of Lewis Henry Morgan's anthropological classic, *League of the Haudenosaunee* (under contract) and coeditor (with Andrea Smith) of the ten-chapter collection *Theorizing Native Studies* (Duke University Press, 2014). She has articles in *Cultural Anthropology*, *American Quarterly*, *Junctures*, *Law and Contemporary Problems*, and *Wicazo Sa Review*. She contributed to the edited volume *Political Theory and the Rights of Indigenous Peoples* (Cambridge University Press, 2000) and was the volume editor of *Recherches amérindiennes au Québec* (1999) on "New Directions in Iroquois Studies." She is the recipient of fellowships and awards from Fulbright, the National Aboriginal Achievement Foundation, Dartmouth College, the American Anthropological Association, Cornell University, and the School for Advanced Research (Santa Fe, NM). In 2010 she won Columbia University's School for General Studies Excellence in Teaching Award. She is a Kahnawake Mohawk.

1
As a group of Indigenous adults argue about whether to save their government housing or their sacred landscape, their children struggle to decide how the ancestral Dreaming makes sense in their contemporary lives. Listening to music on their iPods, walking though bush lands, and boating across seas, they follow their parents on a journey to reenact the travel of the Dog Dreaming. Along the way individuals run out of stamina and boats out of gas, and the children press their parents and each other about why these stories matter and how they make sense in the context of Western understandings of evolution, the soundscapes of hip-hop, and the technologies of land development. *When the Dogs Talked* mixes documentary and fiction to produce a thoughtful yet humorous drama about the everyday obstacles of structural and racialized poverty and the dissonance of cultural narratives and social forms (Karrabing Film Collective, 2014).

2
Hal Foster, *Return of the Real* (Cambridge, MA: MIT Press, 1996), 174.

The Urban Intensions of Geontopower

1. Where Is Brussels?

Reflecting on W. E. B. Du Bois's inner state as he walked along Brussels's great park and palace at Tervuren in 1936, David Levering Lewis wrote, "He was vividly reminded that Tervuren was Leopold's conception of Versailles as a museum, twenty cavernous hallways gorged with mineral, fauna, and flora his agents had scooped up, shot down, and cut out of the heart of Africa at the probable cost of ten million black lives."[1] One can hear Du Bois's heels clicking against the polished paving stones and see, as he saw, the copper architectural adornments of elite Belgian institutions as he absorbed the full monstrosity of colonialism. Here was Brussels, a model for a new modern Europe where flaneurs strolled, taking in wonders of new urban life like the "arcades, a recent invention of industrial luxury ... glass-roofed, marble-paneled corridors extending through whole blocks of buildings, whose owners have joined together for such enterprises."[2]

It wasn't merely the glass-vaulted shopping centers that enraptured the young urban class but the unseen infrastructures of electricity, water, and sanitation. The Senne River was a catchment for stormwater and wastewater, "a visual and medical blight on the Brussels city center, a source of flooding, and an embarrassment to the new government."[3] The "Builder King" Leopold II and the Brussels municipal government began covering the Senne from 1867 to 1877, making the sewer invisible to sight but pulsing within the belly of a new gleaming metropole. These water infrastructures were built from industrial trade that had a mediated relationship to colonial worlds. By 1878, having failed to acquire the Philippines from the Spanish Crown, Leopold II seized the so-called Congo Free State. Under the auspices of scientific inquiry and

civilizational uplift, Leopold II would extract the countless fortunes that built Brussels into a wonder of the world and later the capital of Europe on the backs of ravaged Congolese people and lands.[4]

How easy it must have been for city dwellers to relegate the monstrosities of colonial capitalism to places far away, or to encase their excremental flows in materials ripped from elsewhere. How estranged and enraged Du Bois must have felt witnessing the obliviousness of those who walked along these benighted streets, who sipped tea rich in sugar within the houses that lined them, who thought they lived in Belgium and who thought that Belgium was within Europe, and who thought that Europe was outside Africa, Asia, the Americas, and the Pacific; who thought, if they thought about this at all, that they were—and deserved to be—the center of a fabulously unfolding dialectic of the spirit. What Du Bois saw in the urbane politics of loitering was equally if not more nightmarish than the atrocities that led to more than eight million African men, women, and children dead in the Congolese basin. The arcade may be "a city, a world in miniature, in which customers will find everything they need," but it existed in inverse proportion to worlds stripped of every material condition of human and nonhuman existence. What but demons could so thoroughly disavow the sickening conditions of their good life?

Some theorists attempted to pull the mask off this illusion after the Second World War. Hannah Arendt would insist that the origins of the Holocaust were in European imperialism, but in the process would distinguish between colonial and imperial worlds in ways that iterated the European account of Indigenous peoples in Australia and the Americas as "two continents that, without a culture and a history of their own, had fallen into the hands of

Europeans."[5] Aimé Césaire would make no such distinction. Colonialism pulsated through imperialism. And "colonialization works to decivilize the colonizer, to brutalize him in the true sense of the word, to degrade him, to awaken him to buried instincts, to covetousness, violence, race hatred, and moral relativism ... [E]ach time a head is cut off or an eye put out in Vietnam and in France they accept the fact, each time a Madagascan is tortured and in France they accept the fact, civilization acquires another dead weight, a universal regression takes place, a gangrene sets in, a center of infection begins to spread."[6] The decay just looked different when viewed from the sacred landscapes of colonial Congo than when viewed from the top of Brussels's Royal Museum for Central Africa. As Césaire's student Frantz Fanon noted, the colonial world is not only where colonizers go. It is a system that encloses city and suburb, country and wasteland, and the roads and waterways that provide or are carved to provide transport. All roads lead to Rome, because no matter how far from Rome they are built and toward what unknown territory, they are built to move anything of value in only one direction.

The great cities of Europe are technological condensations and displacements of countless despoiled and depopulated spaces—what have become the rural and wasteland areas along and beyond their peripheries. The minerals dug out of Congo, South Africa, Australia, and Canada went somewhere. In other words, they are not merely the accumulation of an abstraction (surplus value) or a double abstraction (surplus value of surplus value), but a material redistribution and transformation: the shapes of European cities that were taken from colonized landscapes and the tailings of toxins, the rivers of poison, and the mountains of

mudslides engulfing entire communities that came with them. As Europeans crossed and recrossed the globe pulling out what they needed and leaving behind what was superfluous to them, a new hegemonic order of things was created: an emergent and exploitative Western classification of existence, or in other words, what was what and how each related to each other. The hegemonic force of this order of things was secreted in the emerging routes such that things could be used and moved only if they appeared as one kind of thing. These different logics of use and abuse certainly included what was grievable, what was killable, and what could be destroyed in order to enhance someone else somewhere else. If you are the subject of capitalist extraction (which everyone is but not qualitatively or quantitatively equally) and you wish to eke out an existence, then the everyday ethical, social, and political hierarchies and differences of things have to be treated as if their materialities do not matter.

At this point in time, the dynamic of colonial and postcolonial accumulation seems much messier than promised by the crisp dialectics of Hegel and Marx and out of which Césaire and Fanon originally built their critique. Accumulation has less the look of a precisely rendered logic and more of a harvesting machine worthy of science fiction: a massive earth-destroying Death Star ripping and gutting a million worlds and then returning to re-ravage them as many times as it can find new forms of extracting profit from existence (or in the language of capitalist disavowal, "creative destruction"). The wheels of the machine do not go forward, they go backward, side to side, and around and around. Capitalism as such emerged from a mad circle of primitive accumulation: scraping value out of the bodies of enslaved West Africans, pulling nutrients

from Caribbean soil, and casting gunpowder recipes from Chinese knowledge.[7] But this primitive accumulation, Glen Coulthard has argued, depended on an originary accumulation of Native American lands—a Caribbean rid of Caribs, an American South without the Caddo, Seminole, Catawba, Cherokee, Shawnee, and hundreds of others. Coulthard insists that David Harvey's understanding of capitalism as accumulation by dispossession depended on an initial dispossession.[8] Forward into visions of semiotechno-capitalist solutions and industrial climate toxicity: as T. J. Demos, Bron Szerszynski, and others have discussed, numerous such liberal, neoliberal, and libertarian geo-engineering projects figure the anthropos "as ultimate self-creator, for whom no challenge—climate change, agricultural failure, artificial intelligence, planetary hunger, even death and extinction—will be beyond technological overcoming, especially when matched to Silicon Valley capital."[9] Lifted up, lifted out, anthropos was claimed to be different from and superior to all other forms of existence. But this anthropos is not Man. It is a toxic imaginary brewed out of specific colonial and capitalist sociality.

Great cities rose from the smolder; and within these cities new topologies of glistening paving stones and stinking alleyways. As human and nonhuman worlds were ripped from one place to produce wealth in another, the great harvester would return, digging deeper into previously ravaged spaces, this time with imperial and corporate armies to reorganize "free" African labor for mines, plantations, and the construction of new megalopolises in the Global South. The interior contours of these new cities have been understood and documented ever since Engels's *The Condition of the Working Class in England*, continuing on

through Mike Davis's *Planet of Slums*. Likewise, countless studies have detailed the dynamics that drain human and nonhuman materials and values from outside the city, accelerating the process by which urban centers grow and rural areas become vast reservoirs of toxicity. This is what Du Bois saw: material and social space being bent to distortedly sculpt Routes and Worlds, including the means of connecting by differentiating between the urban and rural and the city and its slum. Human and nonhuman existence was forced into specific forms as the condition for movement (what roads demanded; ocean ways allowed; undersea cables provided; low-earth, mid-earth, and geostationary space satellite networks oversaw). The conditions of existence in one place stretched way beyond its location, but in ways that seemed disfigured only to some. (Rising rents in renewed American cities condemn the precariat to lives lived on buses commuting to low-wage work from new suburban ghettos.) But this idea that toxicity could be kept at a distance was always a fantasy. This fantasy has now been punctured. The toxic waterways they sealed far away from their view or right below their own feet are now overflowing.

Critical Indigenous Theory has long argued that colonialism did not merely destroy people and their lands, but attempted to destroy myriad non-Western understandings of the irreducible entanglement of human and nonhuman existences that challenge the toxic imaginary of colonial and capitalist extraction. In colonial conditions, the bargain between colonial invaders and Indigenous peoples was never for either your goods *or* your life, it was always both your modes of life *and* your goods. Thus, at the heart of Coulthard's analysis of originary dispossession is this aspect of the harvesting machine:

If we base our understanding of originary dispossession from an indigenous standpoint, it's the theft not only of the material of land itself, but also a destruction of the social relationships that existed prior to capitalism violently sedimenting itself on indigenous territories. And those social relations are often not only based on principles of egalitarianism but also deep reciprocity between people and with the other-than-human world.[10]

Countless deeply reflexive practices of how one belongs across and in existence were disrupted, dug up, and run over as Europeans went southward and westward to make their cities, neighborhoods, and livelihoods. Coulthard is not arguing that settler colonialism burned these worlds down to their root, nor that the effect of this destruction flowed in only one direction. Rather, the harm had different forms and temporalities. The gangrene took root in colonizers as soon as they began treating the Americas as something to be conquered, but the gangrene was slow-acting. They could postpone the effects of the poisons they were creating by moving away from or exporting the poisons they wrought. At some point there would be no further, no behind, no over there. Today may be that day. Peer down into the gutters, follow the flows of water, of metals, and the pollutants they carry and disperse.

2. What Is Geontopower?

At the heart of the colonial ordering of things is geontopower: not a division of things as they are in and of themselves, but a governance of other regions of existence and their meanings, imports, and uses. And at geontopower's core is the carbon imaginary; an intersection, not a correspondence, between Western sciences of life and death and Western

philosophies of the event and finitude. These sciences and philosophies stage the drama, ethics, and singularity of Life against the horror of the inert, inanimate, and insensate. Life is situated against a cold grayness of an original lifeless space, whether eyes are trained to witness this lifelessness in the sublime granite expanse of the American Rockies, the ancient craters of Earth's moon, or the winds of intergalactic space. In geontologic imaginaries, the Desert is Life's nemesis, and controlling the pathways of potable water its prerequisite.

In the Global North, geontopower might appear to be a formation of power succeeding biopower. There we hear the sounds of a growing realization, in the natural and philosophical sciences, that the division between Nonlife and Life is not only an artificial and superficial understanding of the interdependencies of all forms of existence, but also, in the wake of climate toxicity, downright dangerous. But geontopower is not a new formation of power. This division, and the hierarchical relations it creates, has long operated "in the open" in settler colonialism. It allowed colonialism and capitalism to sever and then to relate a hierarchy of things, rights, and values—the rock and mineral, the Indigenous and Black, the white and his glorious future. All these divisions were knotted and reknotted in ways that sought to maintain the purpose of the colonial order of things: the contouring and channeling of all and anything toward a European surplus. In other words, the geontological division of Life and Nonlife is not merely a division but an opportunity for a set of further divisions as maneuver: the civilized and primitive, the white race and others, *Dasein* as the world-rich standing up and apart from the world-poor with no world at all. Indeed, the world's rich were promised so much if

they agree to these divisions and hierarchies: the rock, the native, the Black, the white. The divisions and hierarchies of Life and Nonlife, the animate and inert, the fossil and the rock, functioned as a framework within which colonizers made sense of and justified their minor and major atrocities. The ravagement of lands? The dominion of life over the lifeless; man over nature. The extermination of people? The divisions of life as it unfolds into greater civilizational complexity, humans over the animal world, Europeans over everyone else. Thus, as Christina Sharpe has noted, this division allowed other difference and relations, such as the colonial dynamics that pitted Native Americans and Africans against each other.[11] Little wonder then that the United States lined up police equipped with "more than $600,000 worth of body armor, tactical equipment and crowd control devices" to rip through and run over the originary politics of Standing Rock.[12] Capitalism depends on creating by destroying and then erasing the connections between the material wastes it leaves behind and the glimmering oasis of privilege this waste affords.

 Hopefully this quick summation provides some sense of what geontopower means.[13] But what does geontopower seek to be? Does it seek to be a minor note in an illustrative line of questions: What is Enlightenment? What is Critique? What is a Concept? Is geontopower a moment of left enlightenment? Is it an instance of critique? Is it a concept? Human liberation from the tutelage of his traditions? The human decision to be governed differently? The transformation of what is but has yet to be? If geontopower is a concept oriented toward left progressive critique, for instance, does this mean that in being a concept, geontopower inaugurates an event with a homogeneous application

everywhere, without remainder, and without itself being affected by its movement across territories? In other words, does geontopower equally and effectively describe processes happening in the multiple hearts and edges of cities as well as megalopolises, rural enclaves, and winding deserts? And is such a territorial scope and resilience—a quality of things that can be said to be universal—necessary for a concept to act as a concept as such?

My answer is no. Moreover, geontopower seeks to understand what is being done when a concept aspires to such jurisdiction. In order to suggest what I mean by this, let me review what I think are two fairly uncontroversial claims implicit in everything that I have been saying so far. The first is that the worlds Europeans encountered had understandings of human and nonhuman reciprocity deeper and richer in practice and analytics than any model which proposes, with more or less analytic sensitivity, a singularity (animism), a dualism (animism and totemism), or a quadral (animism, totemism, naturalism, analogism) of the other. And this is because *even if these concepts capture some general actuality*, within all of them were, are, and always will be multiple possible and actual analytic otherwises. This is true for a very simple reason. Actuality is riven with specific and continual human and nonhuman movements, shifts, and adjustments. Each and every one of these shifts and readjustments are taken into or ignored in accounts of why and what for—why a creek gave no fish, why the sky went dark, why my son died rather than yours. Every shift opens more than one, if not an infinity, of possible ways of interpreting an event, quasi-event, and intensification without eventfulness even within any one generally agreed framework of existence—and even if the interpretive possibilities are ignored. In

other words, there is no reason to assume that the worlds Europeans encountered operated like badly programmed computers following principles carved in stone and recited by rote. No matter how perfectly elders passed down oral texts from generation to generation, these texts encountered lands and nonhuman beings in constant movement and adjustment and thus could be interpreted and reinterpreted.

This leads to my second point. As against dominant Western understandings, there is not reason to conflate creativity with a violent interruption of the past or with an inauguration of a new future. Pre- and anti-colonial worlds need not rip time in order to create, nor did they need to refuse time in order to remain the same. A constant attentiveness to the adjustments and innovations necessary to keep human and nonhuman forms in a co-constituting relation was a creative core to the *ancestral present*. This ancestral present is something always being kept in place. The viciousness of settler and other forms of colonialism made this ongoing task critical.

I highlight these two points to open a space in which geontopower resists any attempt to interpret it through a universalizing or homogenizing framework. For instance, in early genocidal colonialism, division underlined colonial claims about primitive mentality. Those people refusing the division were laminated into a geological metaphor to produce a Stone Age People lacking in creative powers and doomed to dumb repetition. As mineral, stone people and their lands could be laid to waste under the cover of the advancement of Life (*Dasein*, enlightenment, civilization). The more they insisted—the more they resisted by force of arms or argument—that they would be governed according to their analytics of existence, the more colonizers sutured them into the infertile stubbornness of stones. They were things that refused to

undergo creative destruction, dialectical evolution. Unmoving colonial and capital forces moved them to whatever lands were considered without value. If precious minerals, ores, and tar sands were discovered, then a new process of forced removal would begin again. It was under the constant deforming pressures of radical disregard that colonized worlds struggled not to be governed by colonial forms of existence and to continue to be governed by their own.

I don't think we need to look into the past to understand what is at stake. We can instead listen to how many, or at least some, within contemporary cities and suburbs now treat the stubborn resilience of Indigenous people, a resilience stretched across centuries of dispossession, bullets, and boarding houses. As cities from Cape Town to São Paulo, Istanbul, Cairo, Beijing, and Phoenix go dry, poisons spread out of their encasements, and previously wealthy colonizer states face massive infrastructural bills, we now hear a new attitude toward Indigenous people on the horizon. Their "mythic knowledge" is now understood to have been a sort of Cassandra call in the shadow of anthropogenic climate catastrophe. They were right. You are right. We have all been governed by a false division that is not merely wrong in a descriptive sense but dangerous and deadly, something that has lead us down a disastrous road. It may seem, right here, that geontopower emerges as a concept that could have universal interpretive power. But I think the opposite. Why I do takes me back to Foucault's famous repurposing of Kant's question of enlightenment as one of critique:

> A critique is not a matter of saying that things are not right as they are. It is a matter of pointing out on what kinds of assumptions, what kinds of familiar, unchallenged, unconsidered modes

of thought, the practices that we accept rest ... Criticism is a matter of flushing out that thought and trying to change it: to show that things are not as self-evident as we believed, to see that what is accepted as self-evident will no longer be accepted as such. Practicing criticism is a matter of making facile gestures difficult.[14]

Foucault sees this attitude of critique emerging out of a "critical attitude" that "unfolds specifically in the West and in the modern Western world since the fifteenth and sixteenth centuries" as religious struggles and spiritual attitudes underwent a transformation.[15]

As I noted above, for worlds struggling to maintain their resilience in wave after wave of displacement and dispossession, from 1492 through to the present, the question was not merely, or even primarily, the same as the one Foucault outlines. If the question within the European diaspora was how to be governed differently, then the question for others doubled back on and reformed this question. It was how not to be governed by you as *we* creatively keep our forms of existence in existence, as *we* experience the major and minor strains and deformations of settler colonialism, of extractive capitalism, of late liberalism. The question was not simply "to show that things are not as self-evident as we believed, to see that what is accepted as self-evident will no longer be accepted as such," but how to remain in existence in the existence we understand as true against geontopower as a form increasingly determining everything.

In other words, geontopower is not a concept that aspires to level the differentials of power, but to make these differentials appear across the territories in which the divisions of Nonlife and Life act

as massive shearing teeth in its great harvesting machines. It seeks to make visible those who claim that the West's material wealth—its modern cityscapes, wealth accumulation, and health—need not take into account actions in one place and reactions in another; that one could assume all harms would wash away in the long run, at the frontier, in the end. Against these claims are those who know that this glorious future has always been careening in a toxic cloud toward all of us which, no matter that it will kill all in the long run, always kills differentially in the short run.

3. What Can Be Done?

What would Du Bois make of global cities in the North today—their submerged waterways bursting; their infrastructures, built from the bodies and lands of colonized worlds, crumbling and corroding? If the modern age invented Man within the problematic of finitude (Man understood as/at his limit, as exposed by Foucault in *The Order of Things*), then from the perspective of the colonized this invention did not grow out of the mind of Western self-reflection but out of the actual conditions of its possibilities. The West ripped itself out of one form of tutelage by placing others within another sort. As the Movement for Black Lives argues, the violence against Black persons is not merely visible when police kill African Americans, and largely with impunity, more than other kinds of US citizens, but when white Americans refuse to acknowledge how their intact bodies are internally tied to what Christina Sharpe calls "zones of black killability." The extimate relationship between struggles of African Americans living in Flint and elsewhere must be put in conversation with the refusals of Indigenous peoples such as the Oceti Šakowin Sioux of Standing Rock, and

not as a struggle between them or as a struggle over which form of dispossession and killability should characterize both of their struggles. Let's agree that there are no cities and rural wastelands or suburban enclaves and ghettos but a set of infrastructural relays whose legitimation of violent redistribution is ultimately grounded in geontopower. And let's say that we continually fail to experience these interconnections because of the way geontopower has separated forms of existence—Nonlife and Life, forms of Nonlife (toxic and nontoxic) and forms of Life (Western, non-Western, civilized, noble savage, barbarian, terrorist)—and then to relate these now separate forms through a hierarchy of time, creativity, and history.

What would a politics that aspires to press against these separations look like? A host of activists and scholars have pointed the way.[16] Alongside these games of toxic hot potato are what Nikhil Anand calls a global game of "hydraulic citizenship."[17] In the US, the most recent public example of hydraulic citizenship is the predominantly African American city of Flint, Michigan.[18] The history of the crisis has been narrated.[19] Flint had been placed under emergency management from 2002 to 2004, and then again starting in 2011, initially framed as part of necessary austerity measures. Austerity for some, that is, and not for others. City managers were paid between $132,000 and $250,000 and had the power to "overrule local elected officials, dictate decisions about finances and public safety, terminate or modify contracts and sell off public assets."[20] On April 6, 2013, looking to cut costs, the city's new emergency manager, Ed Kurtz, informed the state treasurer, Andy Dillon, that Flint was leaving the Detroit Water and Sewerage Department and would build its own pipeline to connect to the

Karegnondi Water Authority. Until the pipeline was built, Flint would rely on water from the Flint River, which was widely known to contain high levels of pollution. Instead of immediately treating the water before pumping it into homes, officials decided to take a "wait-and-see" approach. (The head of the state's health department and four other officials were later charged with involuntary manslaughter.)[21] Residents immediately complained. Officials told residents to boil their water, effectively holding individuals responsible for purifying their water supply. The city then pumped increased levels of chlorine into the water system, levels so corrosive that General Motors stopped using Flint waters because of the damage to its metal parts. And before the racialized austerity of water flowed into Flint, other toxins had wafted their way.[22]

Even after Michigan pediatrician Dr. Mona Hanna-Attisha and Virginia Tech professor of civil engineering Marc Edwards sent their analyses of lead and pollutant levels in Flint's water to network news outlets, it arguably took the vibrant force and analytics of Black Lives Matter to puncture the mainstream news cycle. In other words, the systematic differential of toxicity was made a general problematic. Here, William James's understanding of the social location and energetics of concepts is crucial. Black Lives Matter is a concept in this rich sense of the term: it forces a new field of arrangement and emits all sorts of discursive tailings as the potential prefigurative signs for new concepts. Denounced as another form and instance of state violence against Black bodies, a state of emergency was declared by Mayor Karen Weaver on December 14, 2015, and she announced that "water filters, bottled water and at-home water test kits are being provided to Flint residents free of charge

at Water Resource Centers located around the city."[23] The entire city remains under the threat of emergency management as the state struggles to find funds to replace the rotted infrastructure in order to return the city to a clean future.

Let us pause to understand the troubling implications of the liberal responses to the myriad forms of water crises taking place globally.[24] The call to remove toxins, to replace the spoiled area with clean material so as to return people and areas to our common future, points not to a common future but a present refusal. Those who have long benefited from an entangled arrangement, organized through the divisions and relations of geontopower, refuse to become strained or dissipated by a new one. The three steps of remove, replace, and restore shift attention away from the areas which will be gutted in order to create this restoration project and toward those made by turning others into its dump.

Rather than a common and differentiated present, the liberal response to its own distributed toxicity is symptomatic and diagnostic of its blocked and disavowed networks. On the one hand, it is widely axiomatic that some regions are built up and sustained by ripping apart and disemboweling others while, in the process, leaving behind the chemicals needed to separate metals and ores, the fungi that thrive in machine-friendly fields, and the winds and waters that flow differently when trees have been uprooted. Water crises are, in other words, part of a series of small and large events, intensities and intensifications that keep in place a specific entangled terrain of wealth and power. For some bodies to remain in a purified form, other bodies must drink the effluvia—money must be deducted from someone so that it can be added elsewhere; materials to

build the infrastructures of health must be pulled out from somewhere. On the other hand, those who benefit from this uprooting act as if their lives were not obligated to these ravaged spaces—that what happens to them is only related to what is happening to me by some spectral connection.

Rather than "spooky action at a distance," they disavow their relationship to devastation; to the entanglements between their healthy food, clean water, and fresh air and the toxic dumps elsewhere. The answer from white heteronormative households when (once again) forced to acknowledge that there is nothing ghostly at all about the circuits and transpositions connecting the "common" body in one region of the world to another region is that adequate infrastructure should be built for those who have none. In other words, the common body is still not acknowledged to be common. The rich cities and suburbs dig their psyches deeper into disavowal. They refuse to acknowledge that new infrastructure would need to be built from materials found far away from their own neighborhoods, ripped from someone else's land, manufactured in such a way that still another set of lands and peoples become contaminated. What they will never do is allow others to move into their suburbs, or agree that some of the shiny lead-free pipes be ripped up and exchanged with others. And this too is true of nation-states signing climate-change treaties. The very action of signing, or not, disavows that they could not be what they are without the surface and subterranean passages ravaging one area for the benefit of another. As Césaire, Arendt, and Mbembe all argue, the sewers will start overflowing at some point, and then there will be nothing left to consume but one's own spoiled self. Someone has to eat the outcome. Wouldn't it be ethically sensible for those

who produced and benefited from the distribution of commodity and waste to be the first in line to begin spooning it up?

1
David Levering Lewis, *W. E. B. Du Bois: The Fight for Equality and the American Century, 1919–1963* (New York: Henry Holt, 2000), 394–95.

2
Walter Benjamin, *The Arcades Project*, trans. Howard Eiland and Kevin McLaughlin (Cambridge, MA: Belknap Press, 1999).

3
"Belgium," *The History of Sanitary Sewers*, https://web.archive.orgweb/20180816234134/http://www.sewerhistory.org/photosgraphics/belgium/.

4
Adam Hochschild, *King Leopold's Ghost* (Boston: Mariner, 1999).

5
Hannah Arendt, *The Origins of Totalitarianism* (New York: Harcourt, Brace, Jovanovich, 1973), 186. See also Richard King and Dan Stone, eds., *Hannah Arendt and the Uses of History: Imperialism, Nation, Race and Genocide* (New York: Berghahn Books, 2007).

6
Aimé Césaire, *Discourse on Colonialism* (New York: Monthly Review Press, 2000), 35–36.

7
Sidney Mintz, *Sweetness and Power* (New York: Viking, 1985).

8
Glen Coulthard, *Red Skin, White Masks* (Minneapolis: University of Minnesota Press, 2014).

9
T. J. Demos, "To Save a World: Geoengineering, Conflictual Futurisms, and the Unthinkable," *e-flux journal*, no. 94 (October 2018), https://www.e-flux.com/journal/94/221148/to-save-a-world-geoengineering-conflictual-futurisms-and-the-unthinkable/.

10
Glen Coulthard, "The Colonialism of the Present," interview by Andrew Bard Epstein, *Jacobin*, January 13, 2015, https://www.jacobinmag.com/2015/01/indigenous-left-glen-coulthard-interview/.

11
"In *Notes on the State of Virginia*, Jefferson differentiates between the indigenous *social* savage and the African biological or *ontological* savage." Christina Sharpe, *In the Wake: On Blackness and Being* (Durham, NC: Duke University Press, 2016), 78 (italics in original).

12
Blake Nicholson, "More Than $600,000 Spent on Police Gear for Pipeline Protest," Associated Press, December 16, 2017, https://apnews.com/article/sd-state-wire-police-us-news-ap-top-news-bismarck-1fa0605bafa1455da90bf806d5732ccd.

13
For a longer discussion, see Elizabeth A. Povinelli, *Geontologies: A Requiem to Late Liberalism* (Durham, NC: Duke University Press, 2018).

14
Michel Foucault, "Practicing Criticism," interview by Didier Eribon, in *Politics, Philosophy, Culture*, ed. Lawrence D. Kritzman (New York: Routledge, 1988), 154.

15
Michel Foucault, "What Is Critique?," in *The Politics of Truth*, ed. Sylvère Lotringer, trans. Lysa Hochroth and Catherine Porter (Los Angeles: Semiotext(e), 1997).

16
For instance, see Myra J. Hird, "Waste, Landfills, and an Environmental Ethics of Vulnerability," *Ethics and Environment* 18, no. 1 (Spring 2013): 105–24.

17
Nikhil Anand, *Hydraulic City: Water and Infrastructures of Citizenship in Mumbai* (Durham, NC: Duke University Press, 2017). See also Antina von Schnitzler, *Democracy's Infra-structure: Techno-Politics and Protest after Apartheid* (Princeton, NJ: Princeton University Press, 2016).

18
For more background on the Flint crisis, see A. R. Highsmith, *Demolition Means Progress: Flint, Michigan, and the Fate of the American Metropolis* (Chicago: University of Chicago Press, 2015).

19
Summary adapted from Merrit Kennedy, "Lead-Laced Water In Flint: A Step-by-Step Look at the Makings of a Crisis," *NPR*, April 20, 2016, https://www.npr.org/section/the%20two-way/2016/04/20/465545378/lead-laced-water-in-flint-a-step-by-step-look-at-the-makings-of-a-crisis.

20
Susan J. Douglas, "Without Black Lives Matter, Would Flint's Water Crisis Have Made Headlines?," *In These Times*, February 10, 2016, http://inthesetimes.com/article/18843/without-black-lives-matter-would-flints-water-crisis-have-made-headlines.

21
Scott Atkinson and Monica Davey, "5 Charged with Involuntary Manslaughter in Flint Water Crisis," *New York Times*, June 14, 2017, https://www.nytimes.com/2017/06/14/us/flint-water-crisis-manslaughter.html.

22
Andrew R. Highsmith, "Flint's Toxic Water Crisis Was 50 Years in the Making," *Los Angeles Times*, January 29, 2016, https://www.latimes.com/opinion/op-ed/la-oe-0131-highsmith-flint-water-crisis-20160131-story.html.

23
"State of Emergency Declared in the City of Flint," City of Flint, Michigan, December 14, 2015, https://www.cityofflint.com/state-of-emergency/.

24
Anand, *Hydraulic City*.

Mother Earth: Public Sphere, Biosphere, Colonial Sphere

1.

In *The Human Condition* (1958), Hannah Arendt wrote a cautionary tale of two forms of alienation—from the earth (*Gaia*) and from the world (*cosmos*)—that threatened to annihilate not merely some humans, not merely all humans, but to unleash an atomic holocaust on all life. In Arendt's compressed social historiography, this dual alienation was the result of the slow transformation of the classic Greek understanding of the human condition (*vita activa*). For the Greeks, the human condition was based on three kinds of activity: labor (*animal laborans*), work (*homo faber*), and politics (*zoon politikon*). Arendt believed the modern understanding of the same had become based on and oriented to only one kind of activity—labor and its instrumental reason.

For Arendt, the Greeks had it right, the moderns wrong. The Greeks understood all matters of biological life—and thus life and death—to abide in the realm of *labor*. In this framework, labor is the relationship a person has to her body and the bodily functions of others. It is "the activity which corresponds to the biological process of the human body, whose spontaneous growth, metabolism, and eventual decay are bound to the vital necessities produced and fed into the life process by labor."[1] Labor operates on and addresses the world of necessity, of animal needs: placenta, shit, food, drink, shelter, pleasure, productivity, abundance—what Arendt calls the "burden of biological life, weighing down and consuming the specifically human lifespan between birth and death" on the earth.[2] Labor is what humans do to maintain, enhance, and reproduce life. This natality is its key figure, whether represented via Mother Earth nurturing life or animal mothers pushing out their offspring.

But the realm of necessity is merely the natural ground of the human condition. If labor operates in the realm of intimate biological functions and relations, work, the second aspect of the human condition, operates between the worker and her object. The worker has an idea and then attempts to reify it, materialize it, in a durable form. In doing so the worker "provides an 'artificial' world of things, distinctly different from all natural surroundings."[3] Arendt also notes, time and again, that the ultimate purpose of work is "to offer mortals a dwelling place more permanent and more stable than themselves."[4] Labor makes biological beings; work fabricates the world within which they dwell. But neither labor nor work defines the human condition. They are the grounds on which humans can express their truth through a third form of activity, namely, political action in the public sphere.

Many Arendtian scholars understand political action to be the opposite of labor. If labor focuses on the necessities of biological life and intimate desires and passions, they believe political action is possible only when these concerns are radically bracketed and held at bay. For Arendt, "The human capacity for political organization is not only different from but stands in direct opposition to the nature association whose center is the home (*oikia*)."[5] As opposed to the labor of the home, the political action that defines the public sphere doesn't produce *a baby*, *a person*, or *a life*. Political action discloses who someone is—not directly but implicitly, as the person and those around her come to know who she is relative to the mode, timing, and ordering of her speech and action. "The disclosure of 'who' in contradistinction to 'what' somebody is ... is implicit in everything somebody says and does."[6] In short, the public sphere of political action operates openly in a

shared common world where the exchange of ideas occurs "directly between men without the intermediary of things or matter"; "corresponds to the human condition of plurality, to the fact that men, not Man, live on the earth and inhabit the world"; and is oriented toward immortality.[7]

Did you stand up to a racist comment or not? Were you willing to sacrifice your life for the common good of your people or not? Did you invest all your energies into advancing a better idea of political publics or not? In its most robust sense, each individual action has within it the possibility of becoming a world-historical action. If the scope of your action is large enough, no one will ever forget your name. You will become immortal through the forms you instituted.

Leave aside for the moment the meaning of immortality for Arendt, and note instead her distinction between "*on* the *earth*" and "*inhabit* the *world*." This duality is expressed in multiple ways across the text. On the one hand, we are *on* or *of* the earth, as mortal individuals; we live within the rhythms of life, needing to constantly sustain our bodies. This natural state is an unavoidable and necessary precondition to the human condition. But it is only a precondition. To be human, Arendt claims, is to *inhabit* a world. And because this world must be made, this world can also be unmade and remade. And it is the unmaking of her beloved Greek polis and the catastrophic consequences she saw coming—the nuclear destruction of the earth—that motivated Arendt's compressed and fragmentary social history contained in *The Human Condition*.

In order to explain how we got from the classic world of the Greeks to the current world, Arendt tells a story that goes something like this: In the beginning were Mother Earth (*Gaia*) and Father

Sky (*Uranus*), who together birthed a cosmos—a world—for the Greeks. This world parceled human activities among different kinds of people—the realm of necessity (labor) was assigned to women, children, and slaves; the realm of work to a class of male citizens without property or sufficient property to sustain themselves and their families without work; and the realm of politics to those men who were wealthy enough to have others take care of their necessities and fabricate their world. Over time, those assigned to this labor denounced the world as a false place and retreated to philosophical solitude (*vita contemplativa*). In the Christian era, God the Father, a Son born of a Virgin, and a Holy Ghost smuggled into this situation of falseness an attitude of fallenness that viciously turned Christians against the flesh even as they promised life everlasting in/after death. Their followers lifted their voices to Heaven, singing forward to the endtimes. When the end didn't come, the Christians institutionalized an attitude that rejected the earth as a false and fallen place and prayed for a new kind of infallible heavenly body.

Next, in the Enlightenment era a struggle for emancipation ensued between those, such as Kant, who desired to think independently about earthly things and the various Christian sects who claimed power to determine the moral passageway between life and death. Science emerged from the Kantian Enlightenment as a liberated child. Having emancipated earthly beliefs and secularized earthly practices, the natural and social sciences sought to understand the material dynamics of the earth and universe and the societal dynamics of man. Science zoomed into the molecular and stretched outward to the interstellar. If scientists prayed, they prayed for insight into the truth of life processes or for a

more productive form of life. Science invented labor power and biopolitics. It produced treatises, governmental documents, and social movements that figured the human condition as a biological, geological, cosmological journey of life and death.

For Arendt, all these events were forms of action that had unexpected consequences, which is in the nature of action itself. "Action, though it may proceed from nowhere, so to speak, acts into a medium where every reaction becomes a chain reaction and where every process is the cause of new processes."[8] History is thus a cascade of actions that lead to right or wrong turns that ignite other chain reactions that cannot be anticipated, controlled, or reversed. And every action, she said, is folded into how people work—the things they make; the reason they make them; and ultimately the world in which humans dwell. Sometime during the rise of industrial capitalism her moderns began fabricating durable, then semi-durable, then disposable things to be consumed and shat out. In the end the moderns fabricated earth and worlds (*cosmos*)—the social relations of capitalism, poetry and art, politics, instruments and machines—in such a way that all forms of activity were subsumed into the logics of labor, biology, and necessity. Everything started working for the Great Mother Womb or against the Great Mother Womb; everything became oriented to using the earth for the accumulation of a materially richer life. The human condition was eventually reduced to biology, action to biopolitics.

The moderns fabricated for so long and so extensively that the very fabric of earth and world was now part and parcel of food and toilet. They created the environmental conditions that altered the very nature of their material existence, to paraphrase Marx, as skies were clogged with

smog, famine spread, and vast toxic dumps boiled over. Up above, Sputnik swirled, shaping viewers' understanding of the earth as a limited thing that all humans shared. But the more they treated the earth with concern, the more earth itself became just another object to instrumentalize existence, as if the earth were just another object to consume or not consume, as if consumption were the only way to view each other and the planet. The earth had become the Greek woman and slave, whose truth is assigned to her ability to keep on giving without ever becoming exhausted. Perhaps, we thought, we should find other earths revolving around other stars to begin our ravenous consumption anew.

It was against the shadow of these changing social configurations and the worlds they bore that Arendt warned of a coming atomic firestorm. She asked: "Should the emancipation and secularization of the modern age, which began with a turning-away, not necessarily from God, but from a god who was he the Father of men in heaven, end with an even more fateful repudiation of an Earth who was the Mother of all living creatures under the sky?"[9]

You might think Arendt's vision of Earth consumed by nuclear fire would orient her toward heaven, or to outer space, perhaps hanging out her thumb for a ride on Sputnik to Mars—or maybe picking up a shovel and digging a luxurious bunker where she could wait out the end-times, reading ancient Greek classics. But you'd be wrong. Her argument was that the reflex to flee was a symptom of the problem rather than a solution to it. All three forms of world—Christian eschatology, pure science, and biopolitics—set their sights on life, death, birth, and mortal health or corruption, whether from the perspective of the universe, the species, or the individual. In dangerously misunderstanding the human

condition as primarily about life and death, all three were accelerating the crisis.

Arendt believed that no one can escape the human condition through a retreat into solitude or an escape to heaven or the stars, because the human condition is not found in individual solitude, in life and death, or in the after- or everlasting life. The desire to rush away from the earth in order to survive it is exactly what placed moderns on the precipice of total annihilation. If we are to save our lives, Arendt argues, we must turn back to world and earth, but not back to life (labor) or the hope for bodily resurrection (a form of life cleansed of bodily decay). We must leave the obsession with mortality and strive to become immortal, to stay in the world in a way begat by activity independent of the labor of the mother and the law of the father. We need to act in such a way that we make ourselves legend. We need to understand the human condition itself as a form of political action oriented to the common good and enacted "through words and persuasion and not through force and violence."[10]

At this point, Arendt makes a specific philosophical judgment about what sort of world humans must dwell in if they are to avoid the firestorms resulting from earthly and worldly alienation. This world demands we separate the public sphere from the realm of labor and work. But *we* don't do anything. Only certain kinds of people and certain forms of existence are allowed to decide their destinies through persuasion rather than hegemony, force, and violence. Other bodies are assigned to the labor of necessity—wiping up poop, lovingly scooping food into children's mouths, laboring in mines and factories, left at the edges of roads and cities to fend for themselves—as if it were the truth of their being or a fact of nature. For the Greeks it was women and

slaves, for capitalism the proletariat and precariat, for imperialism and colonialism persons of color, Indigenous peoples, and of course Earth herself. This type of labor can leave one exhausted. It can even lead to a hope for death. Christianity, as Hegel said, was the god of exhausted slaves.

Who will be assigned this burden of necessity today? As Arendt notes, we cannot reverse the cascading effects of political action. We now live in a world in which assigning certain classes of persons to bear the burden of maintaining life is no longer, if it ever was, politically viable. Enter the machines. The cybernetic technicians at the control panels of military-mediated techno-science reassured the world that soon machines would be able to think, and in thinking solve the problems of labor and life. In a 1964 lecture at the Conference on the Cybercultural Revolution, Arendt took aim at several assumptions within the cybernetic community.[11] One of the great benefits of cybernetic machines that engineers touted was the liberation of humans from labor and the creation of a world of endless leisure. Computer automation promised to take over fabrication. With its utopian and dystopian visions, cyberpunk soon began imagining a world run by machines, exemplified in Philip K. Dick's *Do Androids Dream of Electric Sheep?* (1968).

All Arendt could see was a coming hell of endless nothingness. "Vacant time is what it says: it is nothingness, and no matter how much you put in in order to fill up this nothingness, this nothingness in itself is still there and present and may indeed prevent us from voluntarily and speedily adjusting ourselves to it."[12] The leisure afforded by cybernetics, she thought, would simply accelerate the subsumption of the human condition into the logics of labor. Ditto with the new environmentalism

and animal rights movements—in an effort to place humans into a broader environmental ethics, these movements reduced humans to a pure biology. Only if cybernetics managed to free all persons from necessity so that they could enter the political realm—similar to how the Greeks had liberated certain men from necessity by locking up women and enslaving other people so that men could act politically—could it enhance the human condition. Then it could help moderns step back from the precipice of a great catastrophe. In this view, machines would be the new woman, slave, colonized person, and subaltern subject. Robots would speak Greek, in the sense that they could be assigned the labor of necessity as if it were in their nature to do so. Thus we should not be surprised today that the voice of current AI programs like Siri sound like the fantasy girlfriend of the (likely male) code-writer. She keeps giving and giving and never turns her back. Robots seem perfect for this role, insofar as they are on the other side of Life for Arendt: not merely dead but essentially Nonlife; not merely world-poor but world-absent. Isaac Asimov's *I, Robot* (1950) had something to say about this future for robotics.

If robots can fall out of the moral realm, it is because the materials they are built from—the magnesium crucial to making steel, the rare earths, the polymers of plastics—have never been allowed in. And excluded with them is anyone who understands a different ontological relationship between land and people. Like Arendt, the Australian Goenpul theorist Aileen Moreton-Robinson discusses an irreducible immortality at the root of her people's condition. But this immortality is established by ancestral beings, "creatures of the Dreaming who moved across country leaving behind possessions which designate

specific sites of significance ... metamorphosed as stone or some other form."[13] The "inter-substantiation of ancestral beings, human and land" is the original "ontological relationship" through which all embodiment emerges.[14]

Alongside the Greek cosmos are other dwellers of world and Earth—Dene, Sioux, Ogoni, Karrabing, and so many others. For them, the catastrophe Arendt warns against has already happened—it resulted from the geontological presumptions that invaders brought with them and fabricated their governance out of. The cascading effects of colonization were just now creeping up on Arendt's moderns. Maybe the problem wasn't letting the *animal laborans* take over and transform the rationale of politics, but rather thinking that someone or something has to be assigned the role of providing the biological conditions of someone else's life—that someone must do labor and be the milk for me—and that someone or something can be found to play that role without harm.

2.
Ancient Greece is the comfort blanket for Arendt's moderns and their legatees. Whenever in crisis, they reach toward it for support. Like toddlers reaching toward their mother's breast when feeling unsafe, they wrap their lips around the logos of classical men. Pick me up. Fix it. The sounds of the words are comforting as they blend into the words they already had given their actions and institutions: *demos*, *logos*, *nomos*. As her grandchildren rip into her flesh and shit in her belly, Gaia herself seemed to stretch her hands to the Sky Father and pray: "Anything Lord, anything but this." Many now run to her defense. Gaia: ignoring Arendt's caution, theorists call out her name as object and subject of

care. In the 1970s James Lovelock and Lynn Margulis, and more recently Bruno Latour, used Gaia to think through a looming global environmental catastrophe. But most prominently there was the anthropologist, cyberneticist, psychologist, and morphologist of being Gregory Bateson. By 1979 Bateson was proposing "the biosphere" as a technical name for Gaia, the two terms interchangeable for him, both meaning the highest order of mind and life.[15] But in giving Gaia a new name he not only rejected Arendt's caution, he also rejected another possible way of understanding the interconnections governing existence, namely, the colonial sphere. In choosing the concept of the biosphere, he disclosed the manner in which Western epistemology governs difference.

Bateson had a very specific understanding of what mind was, and thus what criteria had to be met before one could say one was in the presence of it. Difference and relevance were key, or what he called a "difference that makes a difference" (or second-order difference) to another mind. In other words, mind was not a solitary thing, a sovereign substance, or a unified self.[16] Mind is the process of incorporating difference (information) as a kind of difference. Bateson describes this process in many ways, including "stimulus, response, and reinforcement."[17] The core dynamic of mind is this: the mind creates a meta-pattern that is able to reconcile what it is with the difference it encounters. It then becomes this new pattern, in effect ingesting into itself a modified version of itself as altered by the difference. Indeed, mind feeds on the information (difference, noise, chaos) it encounters by classifying (transforming) it into an ingestible form, which alters itself without exploding itself.

For Bateson mind, life, and evolution are, thus, simply three words that refer to the same

thing. As he says, time and again, across his books *Steps to an Ecology of Mind*, *Mind and Nature*, and *A Sacred Unity*, that the evolution of mind (map, meta-pattern) is the core of what we consider life to be. It is what holds "us" in relation to "ourselves" at a given level of bios against the noise of the territory. Bateson believed that defining life/mind in this way allowed him to puncture the dangerous Enlightenment chauvinism that removed the human mind from other parts of nature. Instead, for Bateson, the human mind was merely one region of a much larger biospheric mind, a part of a larger play of life forces partaking in difference, relevance, and self-correction. Thus not only is the "individual mind" immanent in the body, "it is immanent also in pathways and messages outside the body; and there is a larger Mind of which the individual mind is only a subsystem. This larger Mind is comparable to God but it is still immanent in the total interconnected social system and planetary ecology."[18] Sounding as loud an alarm as Arendt but grounded in an entirely different life of the mind, Bateson argued that if the West failed to devise a new ecology of mind, a general ecological collapse threatened all life on Earth:

> Let us now consider what happens when you make the epistemological error of chasing the wrong unit: you end up with the species versus the other species around it or versus the environment in which it operates. Man against nature. You end up, in fact, with Kaneohe Bay polluted, Lake Erie a slimy green mess, and "Let's build bigger atom bombs to kill off the next-door neighbors." There is an ecology of bad ideas, just as there is an ecology of weeds, and it is characteristic of the system that basic error propagates itself. It branches out like a

rooted parasite through the tissues of life, and everything gets into a rather peculiar mess. When you narrow down your epistemology and act on the premise, "What interests me is me, or my organization, or my species," you chop off consideration of other loops of the loop structure. You decide that you want to get rid of the by-products of human life and that Lake Erie will be a good place to put them.[19]

The reference to Kaneohe Bay would have been well known to Bateson's readers. The bay was a case study of the effects of the common practice of dumping raw sewage into rivers, bays, seas, and oceans in the late 1960s. Lake Erie, so heavily polluted by industrial contaminates from the Cuyahoga River that flows into it, caught fire, helping spur the environmental movement. The toxic consequences of toxic liberal capitalism were hardly contained to one beach and bay. Eighty people died in New York City in 1966 when the temperature rose, intensifying smog.

And yet, to Bateson, the Cuyahoga River was not itself a mind. Indeed, many things fell outside of Bateson's category of mind—stones, manganese, water, telescopes, and windup toys. "There are, of course, many systems which are made of many parts, ranging from galaxies to sand dunes to toy locomotive," but these are not "minds," nor do they "contain minds or engage in mental process." "The toy locomotive may become a part in that mental system which includes the child who plays with it, and the galaxy may become part of the mental system which includes the astronomer and his telescope."[20] Yet, without the child and astronomer, they are merely things in the world, rather than world-rich in themselves.

What, then, of those peoples who do not consider rocks, rivers, and sand dunes as without mind—those I mentioned above, such as the Goenpul, Dene, Sioux, Ogoni, and Karrabing, but also the Native American Seneca, who belong to Cuyahoga? And what of the Papua New Guinea Sepik River peoples and those residing in the Balinese village of Bajoeng Gede, among whom Bateson lived in the 1920s and '30s, and among whom he developed his key concepts of schismogenesis and the double bind? Where did Bateson place them in his ecology of mind? Biographies note the initial frustration Bateson experienced during his Papuan fieldwork in the 1920s.[21] Originally a student of zoology, Bateson shifted to social anthropology under A.C. Haddon, who urged him to study contact between the Indigenous Sepik groups in Papua New Guinea and their Australian colonial administrators. After being excluded from the secret ceremonies of one group and after deciding that another was too culturally contaminated, he shifted his attention to the Sepik River Iatmul. Later, with Margaret Mead, he studied the social relations of Bajoeng Gede Balinese.

For Bateson, Sepik and Iatmul and Balinese men and women were certainly not windup toys. For him, they aspired to be more like rocks. They sought not to evolve. "The rock's way of staying in the game is different from the way of living things. The rock, we may say, *resists* change; it stays put, unchanging. The living thing escapes change either by correcting change or changing itself to meet the change or by incorporating continual change into its own being."[22] Although he purported to study change resulting from contact, he ultimately desired to find authenticity, which he considered that which had not changed. More accurately, he sought out those who resisted the onslaught of colonialism, and then

he characterized this active political resistance as a form of unchanging stasis. The role these people played in Bateson's ecology of mind was classically colonial. They provided him a form of difference that would energize his own internal unfolding. In continually encountering distinct regions of mind (among them the Iatmul, the Balinese, US military intelligence, Western science and epistemology, new age ecology), he enriched himself with the selves of others. He became Hegelian, the mind that actualized Geist by understanding the meaning of Napoleon's cannons at the gates of Jena.

 I am being a tad unfair. Bateson was more humble than Hegel. He claimed knowledge could never be actualized, because mind was founded, as Deleuze would later put it, on original multiplicity.[23] Still, the itinerary of Bateson's historiography of mind followed the rhetoric of Western civilizational self-aggrandizement. The great Martinican Aimé Césaire agrees with Bateson's belief that contact between civilizations is what keeps each from atrophying. But he quickly and searingly mocks Bateson-like ideologues—all those who see Western knowledge as emerging from a benign encounter with difference. Europe's "great good fortune," Césaire sarcastically writes, was "to have been a crossroads, and that because it was the locus of all ideas, the receptacle of all philosophies, the meeting place of all sentiments, it was the best center for the redistribution of energy."[24]

 In his 1990 *Poetics of Relation*, another Martinican, Édouard Glissant, compares the worlds of invading Christendom with the worlds they encountered, according to their differing forms of nomadism. In the "circular nomadism" of people such as the Arawak, hired laborers, and circuses, "each time a portion of territory is exhausted" they

move on to a new place, only to come back when it has regained its resilience. By contrast, the goal of invading nomads was not to allow a place to replenish itself but "to conquer lands by exterminating their occupants. Neither prudent nor circular nomadism, it spares no effect. It is an absolute forward projection: an arrowlike nomadism."[25] Eventually the invaders begin settling down, rooting in, claiming hold, and forcibly moving others into their fortresses via the dark, diseased holds of slaving ships. The invaders' descendants begat descendants, who eventually realized they had shat where they were now going to eat, and so created new exterior and interior toilets. They sent toxic forms of manufacturing into interior reserves of difference—native lands, regions dominated by persons of color and the poor—and external third worlds.[26]

In short, the good fortune of Europe and its progeny came not from an advanced ecology of mind, as Bateson suggested, nor from the perversion of a Greek understanding of the human condition, as Arendt would have it. It came from its parasitical relationship to others. The scrabble of competing kingdoms of Western Christendom rampaged across what they called new worlds, as if the worlds were part of a gargantuan female body, ripe for the taking and easily disposable when used up. They carried Greek lexicons as they invaded land after land, justifying their savagery in classical terms, then settling down into a demos that claimed within it "a hierarchy of logical types immanent in the phenomena."[27]

As Hortense Spillers noted long ago, this cosmos is more legible in an American rather than Greek grammar.[28] Thomas Jefferson, erudite scholar of the classical world and slave owner, parsed out hierarchies of flesh and bodies by differentiating between the social (Indigenous) and ontological (African)

savage.[29] This uniquely American grammar reveals how the American demos was built by sorting non-Europeans into the orders of the world-absent and world-poor, the rocks that could be treated as mere objects versus the animals who simply had not yet become fully civilized—those of mere flesh and those with a body.

Europe used its cosmos to justify sinking its teeth into worlds of others and sucking out whatever resources were available until it swelled into a blood balloon. Blood balloons became nations. Their people (*demos*) became Americans, Australians, Canadians, New Zealanders, English, French, and Germans. Europe did not simply create what Césaire's student Frantz Fanon would famously call the Wretched of the Earth. Europe created itself through the parasitical absorption of others. "The wealth of the West was built on Africa's exploitation," notes Richard Drayton, and also on the exploitation of South Asia, the Pacific, and the Americas.[30] Immortality was based on the biggest killing, otherwise known as wealth accumulation. And Europeans did not only drain the labor and life energies of bodies and lands; they also sacked ideas.[31] Césaire writes:

> What, fundamentally, is colonization? To agree on what it is not: neither evangelization, nor a philanthropic enterprise, nor a desire to push back the frontiers of ignorance, disease, and tyranny, nor a project undertaken for the greater glory of God, nor an attempt to extend the rule of law. To admit once and for all, without flinching at the consequences, that the decisive actors here are the adventurer and the pirate, the wholesale grocer and the ship owner, the gold digger and the merchant, appetite and force, and behind them,

the baleful projected shadow of a form of civilization which, at a certain point in its history, finds itself obliged, for internal reasons, to extend to a world scale the competition of its antagonistic economies.[32]

The shadow the invaders cast, the timing and character of their actions, disclosed the truth about their civilizational claims. Europeans before Europe viewed other lands as rich territory to be forcefully acquired, exploited, and then discarded. Hard, vicious work (*homo faber*) fabricated and refabricated multiple worlds and earthly terrains. But acknowledging the power of invader history is different than imagining that invaders had superpowers. As their minds and institutions were formed by gulping the difference they encountered, difference often got stuck in their throats. They choked. Writing almost simultaneously, Césaire and Arendt located the conditions of the Holocaust of the Second World War in the sadisms of imperial and colonial Europe. We can easily see that a similar tide of toxicity is now turning back to Northern shores. The Wretched of the Earth have pulled many "immortals" from their pedestals. Still, those left in the wake of various forms of colonialism and postcolonialism struggle with the impossible possibilities that characterize the aftermath—the math of an after that is ongoing.[33]

1
Hannah Arendt, *The Human Condition* (Chicago: University of Chicago Press, 1958), 7.

2
Ibid., 119.

3
Ibid., 152.

4
Ibid.

5
Ibid., 24.

6
Ibid., 178.

7
Ibid., 7.

8
Ibid., 190.

9
Ibid., 2.

10
Ibid., 26.

11
"Arendt's 1964 Lecture on Cybernetics." Online at: https://www.anotherpanacea.com/2012/06/arendts-1964-lecture-on-cybernetics/.

12
Ibid. See also Brian Simbirski, "Cybernetic Muse: Hannah Arendt on Automation, 1951–1958," *Journal of the History of Ideas* 77, no. 4 (2016): 589–613.

13
Aileen Moreton-Robinson, "Senses of Belonging: How Indigenous Sovereignty Unsettles White Australia," *ABC Religion and Ethics*, February 21, 2017. See also Glen Coulthard, *Red Skin, White Masks: Rejecting the Colonial Politics of Recognition* (Minneapolis: University of Minnesota Press, 2014).

14
Aileen Moreton-Robinson, "I Still Call Australia Home: Indigenous Belonging and Place in a White Postcolonizing Society," *Uprootings/Regroundings: Questions of Home and Migration*, ed. Sara Ahmed (Oxford: Berg Publishers, 2003), 32.

15
Gregory Bateson, *Mind and Nature: A Necessary Unity* (New York: E. P. Dutton, 1979).

16
"The interaction between parts of mind is triggered by difference, and difference is a nonsubstantial phenomenon not located in space or time; difference is related to negentropy and entropy rather than to energy." Ibid., 92.

17
Ibid., 134. Six aspects of Bateson's definition of mind are key: "a mind is an aggregate of interacting parts"; "the interaction between parts of mind is triggered by difference"; "mental process requires collateral energy"; "mental process requires circular (or more complex) chains of determination"; "in mental process, the effects of difference are to be regarded as transforms (i.e., coded versions) of events which preceded them"; and "the descriptions and classification of these processes of transformation disclose a hierarchy of logical types immanent in the phenomena." Ibid., 92.

18
Gregory Bateson, *Steps to an Ecology of Mind* (New York: Ballantine Books, 1972), 467.

19
Ibid., 492.

20
Ibid., 94.

21
David Lipset, *Gregory Bateson: Legacy of a Scientist* (Saddle River, NJ: Prentice Hall, 1980).

22
Ibid., 103.

23
Gilles Deleuze, *Difference and Repetition*, trans. Paul Patton (New York: Columbia University Press, 1994).

24
Aimé Césaire, *Discourse on Colonialism* (New York: Monthly Review Press, 2001), 34.

25
Édouard Glissant, *Poetics of Relation* (Ann Arbor: University of Michigan Press, 1997), 12.

26
Rob Nixon, *Slow Violence and the Environmentalism of the Poor* (Cambridge, MA: Harvard University Press, 2013).

27
Bateson, *Mind and Nature*, 92.

28
Hortense J. Spillers, "Mama's Baby, Papa's Maybe: An American Grammar Book," *Diacritics* 17, no. 2 (1987): 64–81.

29
Thomas Jefferson, *Notes on the State of Virginia* (London: Penguin Classics, 1998). See Christina Sharpe, *In the Wake: On Blackness and Being* (Durham, NC: Duke University Press, 2016), 78.

30
See Joseph Inikori, *Africans and the Industrial Revolution in England* (Cambridge: Cambridge University Press, 2002); Richard Drayton, "The Wealth of the West Was Built on Africa's Exploitation," *Guardian*, August 19, 2005; Ta-Nehisi Coates, "The Case for Reparations," *The Atlantic*, June 2014.

31
Kapil Raj, *Relocating Modern Science: Circulation and the Construction of Knowledge in South Asia and Europe* (London: Palgrave MacMillan, 2007).

32
Césaire, *Discourse on Colonialism*, 32.

33
Sharpe, *In the Wake*, 105.

The Ancestral Present of Oceanic Illusions: Connected and Differentiated in Late Toxic Liberalism

Elizabeth A. Povinelli

Routes/Worlds

I had sent him my small book that treats religion as an illusion [*The Future of an Illusion*, 1927], and he answered that he entirely agreed with my judgement upon religion, but that he was sorry I had not properly appreciated the true source of religious sentiments. This, he says, consists in a peculiar feeling, which he himself is never without, which he finds confirmed by many others, and which he may suppose is present in millions of people. It is a feeling which he would like to call a sensation of "eternity," a feeling as of something limitless, unbounded—as it were, "oceanic." This feeling, he adds, is a purely subjective fact, not an article of faith; it brings with it no assurance of personal immortality, but it is the source of the religious energy which is seized upon by the various Churches and religious systems, directed by them into particular channels, and doubtless also exhausted by them. One may, he thinks, rightly call oneself religious on the ground of this oceanic feeling alone, even if one rejects every belief and every illusion.
—Freud, *Civilization and Its Discontents*

1. Neither, Neither

The geontological division of being between Life and Nonlife is beginning to lose its effectiveness in securing privilege for the settler liberal capitalist elite and in governing the hierarchy of human and more-than-human. As this happens, new conceptual figures and axioms are emerging, new moods are being torn from or anchored to older ones. I discussed three of these conceptual figures (the Desert, the Animist, and the Virus) in my last book, *Geontologies*, and elaborate on four newly arising axioms of critical theory in an upcoming

book, *Between Gaia and Ground*. These four axioms are: entanglement of existence; the unequal distribution of power to affect the local and transversal terrains of this entanglement; the multiplicity and collapse of the event as the sine qua non of political thought; and the racial and colonial history that has informed modern Western ontologies and epistemologies and the concept of the West as such. As with the figures discussed in *Geontologies*, so the axioms examined in *Between Gaia and Ground*: I am not interested in promoting a new universally applicable frame, but rather in helping to amplify the broader anti-colonial struggles from which these figures and axioms have emerged. I also aim to examine a reactionary formation—late liberalism—which has attempted to remold, blunt, and redirect these struggles. After all, these figures and axioms are part of much broader discursive surfaces that reflect opposing currents of political thought and action in the wake of geontopower. The way we approach them—including a seemingly casual syntactic arrangement of theoretical statements—results in dramatically differing paradigms for figuring the present both as a coming catastrophe (*la catastrophe à venir*) and as an ancestral one (*la catastrophe ancestrale/historique*).

Nowhere is this point more important, I think, than in how we approach oceanic feelings, forces, and ancestral presents. From Aimé and Suzanne Césaire, C. L. R. James, Claudia Jones, and Édouard Glissant, through Sylvia Wynter, Christina Sharpe, and so many others, critical anti-colonial and race theory has been written from the specific histories that marked the Black Atlantic. Glissant opens his reflections in *Poetics of Relation* on a boat in the middle of the Atlantic, in the midst of the radical exploitation and dispossession of the West African

men, women, and children "who lived through the experience of deportation to the Americas."[1] Three abysses unfurl on this turbulent sea: the abyss of the belly of the boat, the abyss of the depths of the sea, and the abyss of all that has been severed and left behind. The stakes of what existence is—essence or event—shrinks to a vanishing point relative to, on the one hand, how the world became entangled in these sadistic practices and, on the other hand, how the Relation that opened in this specific scene continues to entangle existence. By anchoring his concept-building in the horror of the slave boat, Glissant does not, however, merely seek, as "every great philosopher," to "lay out a new plane of immanence, introduce a new substance of being and draw up a new image of thought."[2] Nor does he only seek to initiate and provide a new course for old affects and discourses. He does both of these things, yes; but he also does something else, something slightly errant to the obsession of his friends Deleuze and Guattari: he asks whether any concept matters outside the worlds from which they come and toward which they intend to do work. What do we ultimately care about: the ontological status of existence or the modes of being and substance that a specific commercial engorgement of humans and lands produced and continues to engage?

In other words, by commencing from this specific abyss, Glissant reminds us, firstly, that the liberal politics of empathy, of putting oneself into another—acting as if anyone can experience and everyone should act as if they could experience this cavity of being in Relation—is not merely wrongheaded but a continuation of the devasting political relations that opened in the Black Atlantic. This does not suggest that those who were, and are, in a different relation to the Abyss—those who benefit from

the three abysses—should shove wax in their ears and force others to paddle them forward. Instead, the questions are how specifically one has emerged in relation to the ancestral present of this abyss; how the entanglement of existence is not some abstract starting point but the social situations that different persons are given in the present in a world structured to care for the existence of some and not others; and how one can change the given relations that have sedimented into existence from the depths of these seas and severed shores. Glissant also reminds us, secondly, of how cunning the absorptive powers of late liberal capitalism are—how quickly specific relations are remade as relations-erasing universal abstractions. "An abyss opened here for them" is reformulated as "we all live in the abyss." This absorptive, relations-erasing universalism is especially apparent in some contemporary discourses of toxic late liberalism and climate collapse—what some call the Anthropocene—especially those that anchor the crisis in a general Human calamity that, as Sylvia Wynter has noted, is merely the name of an overdetermined and specific European man.[3] Like geontopower, the toxicity of colonialism and its spawn, liberal capitalism, operated in the open in large swaths of the earth where European diasporas stripped and drained away what they saw as valuable and left behind the toxic processed remains that condensed value. Long-standing ecological enmeshments, species relations, and analytics of existence were approached with a genocidal rage or, no less rancid, a callous disregard.

In *The Future of an Illusion*, Freud rehearses the primitivist trope by which man becomes man as such insofar as he is differentiated from animals. Here he is just one of many Western thinkers stretched across numerous disciplinary formations

who assert human difference as a difference of worldedness. Another is Heidegger, with his famous three theses of world distribution: the stone is world-less; the animal is world-poor; and man is world-forming because man's very being (*Dasein*) is always attuned to the world, where being is, by being, irreducibly being-there. We hear this mood lurking behind Hannah Arendt's logic for differentiating colonialism and imperialism. According to Arendt, unlike imperialism, "Colonization took place in America and Australia, the two continents that, without culture and a history of their own, had fallen into the hands of the Europeans."[4] European imperialism occurred much later in Africa and Asia (1884–1914), by which time the earth had become a thing and capitalism had emerged from the engorgement of human and material value in the triangular trade that defined the Atlantic from circa 1500 through the 1800s. No desire to create new forms of human pluralities defined European "adventures" in imperial worlds. Imperial territories were considered solely in relation to what they could provide for the further enlargement of wealth in the metropole. John Adams was not Cecil Rhodes, so Arendt's argument goes, because Adams sought a "complete change of society" in his consideration of "the settlement of America as the opening of a grand scheme and design in Providence for the illumination of the ignorant and the emancipation of the slavish part of mankind all over the earth."[5] Rhodes simply thought of his Rabelaisian body.

 Kathryn Sophia Belle, Fred Moten, and others have written trenchant critiques of Arendt's account of race and colonialism. Moten, for instance, agrees that the advent of settler and slave colonialism in the "Americas" did usher "another way of being" into the world, but the condition of creating this new

common European world was the destruction of a multitude of existing Black and brown worlds.[6] The tsunami of colonialism was seen not as affecting humanity but only these specific people. They were specific—what happened to them may have been necessary, regrettable, intentional, accidental—but it is always *them*. It is only when these ancestral histories became present for some, for those who had long benefited from the dispossession of other people's labor, thought, and lands, that suddenly the problem is all of *us*, as human catastrophe. The phrase "all of us" is heard only after *some of us* feel the effects of these actions, experience the specific toxicities within which they have entangled the world. Let's not have critical oceanic studies be taken by this con—not have an oceanic feeling be that which annihilates the specificity of how entanglements produce difference in order to erase the specific ancestral present.

The following moves the long-standing insights emerging from the Black Atlantic to late liberal oceanic feelings in the Indigenous Pacific. On the surface, the following might seem ethnographic in the sense of a translation project—lots of words, concepts, and analytics that characterize Karrabing understandings of the relations that exist among themselves and their more-than-human worlds. But, as might be apparent very quickly, the purpose is in keeping with Karrabing strategies for how to face the governing forces of settler late liberalism and capitalism without giving away everything in the process. The idea is to provide just enough to know, but no more, since it's not really yours to know—remembering that how you know the world, the moods of the world, and your relationship to it may or may not be part and parcel of the forces of late liberal geontopower.

2. Seaside Conversations

It's March 1985 at a little coastal area called Madpil, in the Northern Territory of Australia. Marjorie Bilbil, Ruby Yarrowin, Alice Wainbirri, some of their children and grandchildren, and I are sitting on the beach at the edge of a mangrove talking over a meal of rice, sea snails, mud crabs, and sweet tea. The city of Darwin is shimmering across the harbor. I met these women, ranging in age from late forties to early sixties, soon after arriving in the Northern Territory in 1984, straight out of my BA in philosophy. Since 1975 they had observed and participated in a contentious land claim over the Cox Peninsula, where Madpil is located. At the center of the peninsula was the community in which they lived, and, for the most part, had grown up and had children. Their parents and grandparents had traveled up and down the coast we were sitting on, dodging and taking advantage of a new virulent pestilence called settler colonialism while they maintained the connective practices undergirding the stability of people's different lands stretching along the coast to Anson Bay some two hundred miles south. These practices included formal rituals that reenacted the ancestral travels of specific *durlg* (in the Batjemalh language; "therrawin" in the Emmiyengal language; "totems" in Anthropological English; "Dreamings" in public English) that created the topology of the region; formal rituals that acknowledged and reflected the durlg-infused landscape's response to the new conditions of the settler pestilence; and ordinary ways of looking out for and caring for land, such as our day spent sweating in the mangrove.

In the 1930s, the Northern Territory government doubled down on the forcible internment of Indigenous groups. The parents of Bilbil, Yarrowin, and Wainbirri were forced into the Delissaville

Settlement at the center of Cox Peninsula. (With the passage of the Aboriginal Land Rights Act in 1976, the settlement was renamed "Belyuen," after its water hole.) From then on, all movement would be strictly monitored by settler superintendents as part of the federal state's new tactic to eliminate the Indigenous otherwise (rather than through murder and violence), through forced containment and assimilation. But the land and its peoples at Delissaville refused the authority of settler law. They came together around the Belyuen water hole and its underground aquatic tunnels stretching to the seaside around the Cox Peninsula and down to Anson Bay. Belyuen was a *maroi* (Batjemalh; "mirrhe," Emmiyengal; "conception totem," Anthropological English) site (a place of dynamic interplay between the spirits of the deceased and the spirits of yet-to-be-born children). Belyuen would keep alive the connective tissue of dispersed places—the ways in which the land was specifically entangled—so that each place could stay alive.

As we rested from a long sweaty slog through the mangrove, Bilbil, Yarrowin, and Wainbirri described struggling to explain to the anthropologists and lawyers working on their behalf to have the lands around Madpil returned to their families how they could at one and the same time have and hold specific coastal lands that hugged the coast of Anson Bay, much further south, and still be irreducibly connected to the lands around Belyuen as well. The creole phrasing that they used to describe the situation was "Mebela got roan roan country, yeah, but they imjoinedupbet got that Belyuen water hole. Belyuen, im now been make mebela properly bla dis country." (We have our own lands, but they are joined to others in an original and ongoing way through the Belyuen water hole. Belyuen made us

properly from here.) Their "roan roan" countries were within Marritjaben-, Marriamu-, Menthayengal-, Emmiyengal-, Wadjigiyn-, and Kiyuk-speaking countries, and included nearly twenty therrawin (Emmiyengal; "durlg," Batjemalh; "totems," Anthropological English). Yes, some of the connective tissue was derived from the topologically formative effects of ancestral durlg who moved across the region, but the effects were not done and dead. They were present and dynamic.

Bilbil used her eldest daughter, AA, as an example. AA was a Murrumurru (Long Yam therrawin) Emmiyengal woman through her father. From notes, Bilbil told me,

> Your edje, im picks up that murrumurru from Mabaluk from im father, though im also think back la my Redjerung [Red Kangaroo, therrawin], Marritjaben side. But im got ingaraiyn maroi (Batjemalh; "mirrhe," Emmiyengal; "conception totem," Anthropological English] from Belyuen, and must be here langa other side, Imaluk. That Belyuen water hole been smellim sweat when me I ben bogey there, and im think, "Yeah, gonna send baby spirit into that sea turtle." So when that old man got that ingaraiyn langa Milik, imself been look and think, "Im different this turtle. Too many seaweed tangled up lei im back." Then AA been come out gamenawerra. Too many hair lei im back. We sebe. Im sign.

She gestured east toward where an Ingaraiyn therrawin sat in the tidal zone as the likely source of the turtle spirit Belyuen sent into an actual sea turtle, which acted as a material conduit into her husband and then her and then her child. As she did so, AA's body stretched and extended (*ex-tendĕre*) into and

across the topological shapings of the ancestral present, folding and pushing inward (*in-tendĕre*) an immanent spacing.

Leave aside hoary anthropological debates about totems and animistic cultures for a moment.[7] Note instead the porosity of modes of embodiment (water, organic bodies) and the multiplicity of connectivities posited as potentially codetermining them substantially. Some are actual, some immanent, all to a more-than-human world that is constantly signing to its human co-participants, who must weigh what is and isn't a sign of a manifestation. A Long Yam site, located at Mabaluk some 150 kilometers as the crow flies from where we are sitting, passed to AA through her father's body ("What this word? What they say, perragut for this kindabet? Here look, Beth, 'patrilineal.'" [What is this word? What do white people say for this kind of connection to land? Here, look at this, Beth. "Patrilineal."]) A sea turtle mirrhe passed into AA from a saltwater encounter between a human, a sea turtle, and a water hole during a hunting event, creating a connection to a Sea Turtle site proximate to where she was born, did the ceremony, and hunted (all sweat). And a water hole inside the community acts as a material communication. It is a site through which ancestral beings travel across aquatic underground tunnels to nearby and far-afield places.

Bilbil, Yarrowin, Wainbirri, and the other Belyuen elder men and women were right. They faced a state law that only recognized (i.e., that *demanded*, as the basis for the return of stolen property) a singular form of human–land relations—some form of a "local descent group" (Anthropological English for "socially inflected biology such as patrilineality and matrilineality"). They also faced the theoretically conservative consultant anthropologists who

wrote reports adjudicating their claim, and the lawyers who read the reports. Both the anthropologists and the lawyers remained puzzled, if not downright skeptical, in the face of questions like: How could these women, and the men of the community, say that their therrawin were always where they were, and were continuing to engage in the same events? How could the unchanging be dynamic, the permanent alterable, and the persistent eventful? Not all anthropologists were confused in this way. Barbara Glowczewski describes a similar reality among her Yuendemu colleagues, in which ceremony pulls into actuality the immanent cartographies that transverse human and more-than-human worlds.[8] These actualizations are the consequences of previous sedimentations that remain beneath and across the overlay of the settler state.

What troubled Bilbil, Yarrowin, Wainbirri, and other older men and women was that anthropologists and lawyers saw all forms of dynamic permanence as somehow less important than the frozen framework of a settler law that recognized only one kind of relation—the descent of man. This was a biological reduction by which their thick relations to the more-than-human were nothing more than a question of what man birthed what person. It was like trying to maneuver across an endless series of funhouse mirrors. As these women described a durlg-determined but dynamic relation to their country, the state and its anthropologists would attempt to redetermine the dynamic by reducing its complexity to a stunningly hermeneutically stupid biology lesson that cut the ties across people and place to produce an enclosed mini nation-state. The land claim dragged on for twenty-plus years; forests were plundered to produce all the law and consultant reports and formal evidence. But under

the guise of liberal recognition, no conversation was actually allowed to occur. As Aimé Césaire wrote in his *Discourse on Colonialism*:

> I admit that it is a good thing to place different civilizations in contact with each other; that it is an excellent thing to blend different worlds; that whatever its own particular genius may be, a civilization that withdraws into itself atrophies; that for civilizations, exchange is oxygen ... But then I ask the following question: has colonization really placed civilizations in contact? Or, if you prefer, of all the ways of establishing contact, was it the best? I answer no.[9]

Some twenty-five years after our conversation at Madpil, I am sitting near a tent camp with many of the now-adult children of Yarrowin and Wainbirri, their partners, and their children. We had grown up side by side as I commuted back and forth from the US two or three times a year. They are living at the edge of the northern coast of Anson Bay, having decided to leave Belyuen. Belyuen had been engulfed by violence, caused in large part by the aftereffects of the same land claim that kicked off the conversation among Bilbil, Yarrowin, Wainbirri, and me in 1985. A piece of federal legislation celebrated as recognizing Indigenous law refused to acknowledge one side of the dynamic that the older women struggled to explain. The Land Rights Commission found one small section of the community to be the legally recognized "traditional Aboriginal owners," even while stating that the entire community had the same rights to the area through Indigenous cultural and ceremonial law. Indigenous law could be recognized as existing but would not be allowed to determine the operation of the state.

The divisions settler law sliced into the community had enormous social and economic consequences. All decisions about how the surrounding lands would be developed were made by only a small group, which also reaped all the benefits flowing from such decisions. The tensions that the state created did not affect the state; they went inward and then exploded.

Told they were strangers in their own land, the fifty-odd men, women, and children and I were discussing how to keep from sliding into destitution but also refuse to open their land to mining. Mining is like a phalanx of circulating capitalist scavenger birds, promising to separate and extract while preserving and enhancing—science fiction inversions of ancestral durlg. Everyone had seen the consequences of such promises: gaping holes from pervious mines, poisoned rivers, and unexplained cancers. Liam Grealy and Kirsty Howey describe "the politico-bureaucratic edifice of uniform drinking water governance and service provision across the NT [Northern Territory]" as "a state-curated fiction" that "produces a racialised 'archipelago' of differentiated islands of drinking water governance."[10]

A couple of people suggested running a green tourist outfit and creating a corporation for it through the Office of the Registrar of Indigenous Corporations.[11] Very quickly, everyone struggled with the state-set trap inherent in this plan. If they selected a place name, say Mabaluk, then the state would immediately consider other family members from adjacent countries and languages as outside, or subsidiary. "Karrabing" was proposed as much for its semantic content as its conceptual pragmatics. Karrabing is an Emmiyengal word referring to when the vast regional tides are at their lowest. Karrabing opens possibilities as it connects distinct

places—it opens fishing, crabbing, and clamming as it shows and makes available the reefs, mangroves, and shore banks connecting ("joining up") the countries of the Indigenous inhabitants of the shoreline. Karrabing was not merely a referential term. It was intended as a concept, foregrounding the dynamic process of emerging and submerging connections across places. For the people who would become the Karrabing, karrabing signals how families best strengthen their relationship to, and the health of, their "roan roan" country by keeping robust the connective tissue between them (*joinedupbet*). They learned this from their parents, who had learned from theirs. This learning is a practice.

Karrabing would become the framework through which a set of land-oriented filmic practices would embody an ongoing resistance to the state's effort to divide and pit Indigenous people and their lands against each other. In other words, making films would not only represent the Karrabing members' views about the irreducible condition of connectivity among the different countries. It would also practice this counter-discourse intergenerationally.

3. Property Relations, Oceanic Feelings

The frustrations that the older women described to me in 1985 when trying to explain to *perragut* (white people as a general category for settlers) how they had their own distinct countries—even while these countries could not be separated into small sovereign fiefdoms—have been mirrored by the surprise many Karrabing members have expressed after encountering audiences for their films inside and outside Australia. No one expresses anger, or even the anguish of Bilbil, Yarrowin, and Wainbirri. But the problem remains, persisting across time and space—the struggle

some perragut have in comprehending these simultaneous statements: "Each of us got our roan roan country from our fathers. Places can't be made separate separate." Two general responses to this kind of statement suggest what is still at stake as critical theory continues to try and break with the concept of sovereign objects. On the one hand, when they describe their durlg relations to their land, Karrabing members are often taken to mean that they own that land. On the other hand, when they discuss the undergirding connectivity between them and the more-than-human world, they are heard to be describing an undifferentiated oceanic feeling, sometimes compared to a colloquial understanding of the Buddhist falling away of all difference.

The first misunderstanding has been under constant pressure in critical theory and Indigenous theory. Aileen Moreton-Robinson has powerfully critiqued the "white possessive" whereby the settler state's gift of self-determination is a demand that Indigenous people mimic the psychosis at the heart of Western liberalism, namely the fantasy of a sovereign body that determines itself, has final say over its use and the use of things within it—that speaks on the basis of its own sovereign self-possession. When Karrabing members describe being a group with multiple lands and durlg stretching across the coasts of Anson Bay and beyond, they see audiences hearing them as saying something like: "I" have a country that is different from his or her country, much as a citizen would say his or her country was distinct from another, or capitalists would say they owned what was theirs. That is, some in the audience hear members evoking a liberal property relation. I often use Mikhail Bakhtin as a counter to this misunderstanding. For him, all words, including "I," are mere rejoinders to a world within us, because it

formed us, before we were us. We can quote him at length from his "Problem of Speech Genres":

> The very boundaries of the utterance are determined by a change of speech subjects. Utterances are not indifferent to one another, and are not self-sufficient; they are aware of and mutually reflect one another. These mutual reflections determine their character. Each utterance is filled with echoes and reverberations of other utterances to which it is related by the communality of the sphere of speech communication. Every utterance must be regarded primarily as a response to preceding utterances of the given sphere (we understand the word "response" here in the broadest sense). Each utterance refutes, affirms, supplements, and relies on the others, presupposes them to be known, and somehow takes them into account.[12]

But often at such film screenings I don't get into long Bakhtin quotes, since Karrabing members, like Cecilia Lewis, powerfully describe their form of belonging to their own lands as an ethical position irreducibly stretched through the other more-than-human worlds of other Karrabing members. In a conversation upending the Judeo-Christian narrative about Babel, Cecilia and other Karrabing members describe not merely an original linguistic multiplicity, but an original ethical relation to the other's language:

> Yeah but here where you talk to det person le you joinimupbet det tubela—and det nuther language where you speak le, that other person dem inside you again. You think bla det person. (Yeah, but here we think that when you speak to

that person in this way, you connect or articulate, you and him—when you speak their language to them the other person comes inside you and you go inside of them. You are thinking of/with/through that other person.)[13]

The land claim legislation clipped all the connecting tissue that provided conditions for holding lands. Karrabing would work to restore this tissue. For Karrabing member Rex Edmunds, this is the connective tissue without which proper caring-for cannot be done. It is materially analogous to how ceremonies must be held:

> Well, you need your uncle or aunt or cousin, in our way it's a cousin, like your mum's brother's kids or your dad's sister's kids to do the burning of the clothes. Because they are your aunt (father's sister) or uncle (mother's brother), they are always from another clan, so another country. Best if the uncle, aunt or cousins are close, but as long as it's connected in this way it's okay. How could I burn my mum's or sister's or father's clothes myself: no one who is in my totem group can touch those things during the ceremony. I am boss of them, but I cannot do it myself. I need my relations from that other totem or country.[14]

Ironically, in the lead-up to the establishment of the land rights law in 1976, the Land Rights Commission noted how this principle fucked with Western notions of property without negating the fact that people knew which lands belong with and to them. One can say that "religious rites [are] owned by a clan," but the rites "could not be held without the assistance of the managers whose essential task it was to prepare the ritual paraphernalia, decorate the

celebrants and conduct the rite."[15] And lest readers reduce the importance of these managers to something analogous to hired labor, the commission notes that the "agreement of managers had to be secured for the exploitation of specialised local resources such as ochre and flint deposits and for visits by the clan owners to their own sacred sites."[16] Rex Edmunds understands this as a strategy by which recognition is a trick severing the relations between groups in order to create hostilities across them.

Karrabing foreground the connective or joint nature of themselves and their lands as they fight against the reduction of their sense to a contractual logic which presupposes the very thing they are fighting against, the irreducibility of the sovereign subject. The contractual imaginary may be explicit, as in a monetary or compensatory debt between two subjects. It can also be affective, such as the feeling of what one owes a mother or a nation. The contractual subject can be a mass subject, such as a nation-state connected to other nation-states by treaties. And it can be an abstract person, as in a corporation. Everyone acknowledges that the realities of such sovereign bodies are messy, and hardly sealed. Human bodies leak inside out and absorb the outside in. State borders become distended, their organs laying on foreign grounds, as governments stretch hearings offshore. How did Australian migration enforcement end up on Christmas Island, on Nauru? How did Haitian interdiction become a maritime affair?[17] How did existential desperation result in the ideology of the political treaty? Moreover, mass subjects bear all the traces of the racial and class logics that compose the proper subject. But whichever way you look at the contractual subject, it has nothing to do with the heart of what Karrabing are saying.

In a video commissioned by the Art Gallery

of New South Wales, Cecilia Lewis, her daughter
Natasha Bigfoot Lewis, and Rex put it this way:

> CL: Like we have Suntu group wuliya Kiyuk
> and wuliya roan. They got their roan place
> and roan story le they roan country. We
> got Trevor mob. They got their own country,
> roan language, roan story. Bwudjut mob,
> they got their own story. Emmi mob
> got their roan story here la Mabaluk.
> Methnayengal got their roan story la Kugan
> mob. But we're still one mob. We different
> language group.
>
> RE: ... but we're one mob.
>
> CL: All one big family down the coast. Married
> family relations.
>
> NL: Because we're connected by the coastline.
>
> RE: And by those stories (ancestral paths
> crisscrossing countries).

This position of interdependent respect extends to the more-than-human world. In a part that didn't make it into the broadcast, Cecilia, Natasha, and Rex discuss some of the ancestral dynamics that demand human attention and commitment. Natasha notes that if Karrabing do not continue to care for ancestral lands by coming and being with them (in the concept of "sweat") then the "land dies; it shuts itself up." Note the qualification of death—the divergence from a geontological understanding. Karrabing understand the "dying" of the more-than-human world as an active withdrawing, a going under, a withholding that in turn can catastrophically transform the human world. Karrabing understand that like they themselves, durlg persist in an ancestrally past, frozen, but ancestral present. Durlg are responsive to the

forces torqueing topology and ecology, now especially the pestilence of extractive consumptive capitalism.

If Karrabing must continually correct those who might unwittingly collapse their understanding of "roan country" into the Western concept of property, they also must combat a second, perhaps stranger evacuation of all specificity between various human and more-than-human worlds. Addressed through the imaginary of People-at-One-with-Nature, Karrabing find themselves cast into an undifferentiated sea, heard to be saying that they are connected to everything, rather than to specific multilayered territories and relations. This is somewhat along the lines of Romain Rolland's 1927 idea of religion as an affective intuition of being not merely connected to the whole of the universe but also being diffused across it, distinct from any specific creedal proposition or theological content. For Rolland, the distinct ground of religion, what distinguishes it from a mere psychic projection, is felt as "an oceanic feeling." Freud responds directly to Rolland in *Civilization and Its Discontents*. At this point, Freud had turned from the technical aspects of his theory to rewriting anthropological and sociological debates from a psychoanalytic perspective. The question of how one accounts for the sources of this oceanic feeling was prompted by Freud's earlier text, *The Future of an Illusion*. There he recast the origins and functions of religion as a recapitulation and projection ("an infantile prototype") of the son's relationship to the father. Man's relation to nature was one of helplessness; as a child, one was helpless yet thoroughly dependent on one's parents, longing for protection from the very people that had the power to destroy you. As Freud put

it, "One had reason to fear them, and especially one's father; and yet one was sure of his protection against the dangers one knew."[18]

The oceanic feeling was, Freud claimed, similarly situated within the dynamics of the psyche, though dynamics that moved one from discussions of the Oedipus complex per se into the formations of the ego. In *Ego and Id*, his earlier text, the notions of Cs. (conscious), Pcs. (preconscious), and Ucs. (unconscious) were supplanted by the dynamics of id, ego, and superego. The ego is an immanent encrustation, a scab, that develops as a membrane differentiated from but sunk within the id's pleasure principle and the superego. In *Civilization and Its Discontents*, Freud emphasizes less the ego as a compromise formation and more the original perennial dynamism that sinks and expands: "An infant at the breast does not as yet distinguish his ego from the external world as the source of the sensations flowing in upon him."[19] Our oceanic feelings come from a time when "the ego includes everything, later it separates off an external world from itself. Our present ego-feeling is, therefore, only a shrunken residue of a much more inclusive—indeed, an all-embracing—feeling which corresponded to a more intimate bond between the ego and the world about it."[20] Using something like Schrödinger's cat, the rest of *Civilization and Its Discontents* tries to suggest how an ancient psychic architecture, unlike the ruins of imperial Rome, are there and not there: "The same space cannot have two different contents."[21]

Not only are we experiencing the infant ego when we experience oceanic feelings. We are not even *feeling* something the infant ego actually felt at the time that her ego had yet differentiated itself as a space between an inside and an outside. Lacan draws on this strange material temporality even as

he alters it in "The Mirror Stage," where he begins to overlay, or excavate, the structural logics of Freud's psychoanalysis.[22] Here is the first glimpse of the retrospective projections that preserve and distort the entrance into subjectivity. Each progression of the Lacanian psyche, its entrance into the Imaginary, into the Symbolic, reactively reconstitutes the content of the previous. Whatever the phenomenological experience of the Imaginary is has been dynamically foreclosed by the Symbolic. The same is true for how entrance into the Imaginary dynamically foreclosed the Real. As Lacan famously put it, the Real isn't reality. Far from it. The Real is a feeling of the undifferentiated absolute, of infinity, of being without having difference, something horrifically compelling and unfathomable because mediated by the Imaginary and the Symbolic. Here we see a similarity to Freud's idea that the infant ego remains, changing to a remainder that cannot remain.

Freud might have swapped the child's psychic development for the truth of a supernatural or metaphysical being. We might wonder whether the reduction of such nuanced specificities that Karrabing describe to a spiritual embrace of some undifferentiated all reflects some other unconscious. It is important to emphasize the difference between what someone like Rex Edmunds is saying when he speaks about his specific *mudi durlg*—how it resides at a specific place; how it reacts to him and him to it because of their ancestrally present relationship; how it is inside and outside of him, passing through the reef and specific fish he encounters; how it is connected to another site to the east, Bandawarrangalgen; and how he and it must struggle to persist together against the ongoing pressures of settler extractive capitalism—and a spiritual quest to experience an undifferentiated

emptiness, or a psychological stage surging up and cracking the crust of the ego. Both sovereign possessiveness and the undifferentiated whole are the unconscious of geontopower. They are two sides of what Luce Irigaray called "the other of the same"; oceanic feeling that seeks to stop being attuned to our specific and different immanent and ancestrally present entanglements is an ideological fantasy, a desire not to face and hold actions and consequences.[23] This kind of oceanic feeling exemplifies the contrasting analytics between toxic colonial liberalism and the Karrabing and others who have long borne the changing moods of colonizing capitalism.

When Natasha Bigfoot Lewis noted the consequence of neglecting one's ongoing relationship with the more-than-human worlds of Karrabing lands, she referenced Karrabing's film *The Mermaids, or Aiden in Wonderland*. *The Mermaids* is an exploration of Western toxic contamination, capitalism, and human and nonhuman life. Set in a land and seascape poisoned by capitalism where only Aboriginals can survive long periods outdoors, the film tells the story of a young Indigenous man, Aiden, taken away when he was just a baby to be a part of a medical experiment to save the white race. He is then released back into the world to his family. As he travels with his father and brother across the landscape, he confronts two possible futures and pasts embodied by his own tale and the timely narratives of multinational chemical and extractive industries. Natasha also knows that the contaminations of colonialism can secrete and sediment below human perceptibility. In a three-channel video work commissioned by Natasha Ginwala for the 2017 Contour Biennale, Natasha and others describe how, in making our second film, *Windjarrameru, The Stealing C*nt$*, Karrabing learned that lands they had long

hunted and camped were contaminated by the toxic remains of an abandoned military radio installation. The nearby perragut community had been informed years before, but not the members of Belyuen. As the older women, their children and grandchildren, and I sat eating our hard-won crabs and sea snails at Madpil, we—but they more than I because I didn't arrive until 1984, and then came and went—were ingesting in these coastal foods the sedimentations of toxic colonialism. Oceanic tides bring in and out these toxicities in all too predictably distributed patterns—the world-poor continue to act as the kidneys of the world-rich.

1
Édouard Glissant, *Poetics of Relation* (Ann Arbor: University of Michigan Press, 1997), 5.

2
Gilles Deleuze and Félix Guattari, *What Is Philosophy?* (New York: Columbia University Press, 1996), 51.

3
Sylvia Wynter, "Unsettling the Coloniality of Being/Power/Truth/Freedom: Towards the Human, After Man, Its Overrepresentation—An Argument," *CR: The New Centennial Review* 3, no. 3 (2003): 257–337.

4
Hannah Arendt, *On the Origins of Totalitarianism* (New York: Harcourt, Brace, Jovanovich, 1973), 186.

5
Hannah Arendt, *On Revolution* (London: Penguin Classics, 2006), 13.

6
Fred Moten, "The New International of Insurgent Feeling," Palestinian Campaign for the Academic & Cultural Boycott of Israel, November 7, 2009, http://www.pacbi.org/etemplate.php?id=1130. See also Achille Mbembe, "Necropolitics," *Public Culture* 15, no. 1 (2003): 11–40; and Patricia Owens, "Racism in the Theory Canon: Hannah Arendt and 'The One Great Crime in Which America Was Never Involved,'" *Millennium: Journal of International Studies* 45, no. 3 (2017): 403–24.

7
Philippe Descola, *Beyond Nature and Culture* (Chicago: University of Chicago Press, 2014).

8
Barbara Glowczewski, *Totemic Becomings: Cosmopolitics of the Dreaming* (Edinburgh: Edinburgh University Press, 2015).

9
Aimé Césaire, *Discourse on Colonialism*, trans. Joan Pinkham (New York: Monthly Review Press, 2000), 33.

10
Liam Grealy and Kirsty Howey, "Securing Water Supply: Governing Drinking Water in the Northern Territory," *Australian Geographer* 51, no. 3 (2020): 341–60.

11
See Elizabeth A. Povinelli, "Routes/Worlds," in this volume.

12
M. M. Bakhtin, "The Problem of Speech Genres," in *Speech Genres and Other Late Essays* (Austin: University of Texas Press, 1987), 91.

13
"Australian Babel: A Conversation with Karrabing," *Specimen: The Babel Review of Translations*, October 31, 2017, http://www.specimen.press/writers/karrabing/.

14
Rex Edmunds and Elizabeth A. Povinelli, "A Conversation at Bamayak and Mabaluk, Part of the Coastal Lands of the Emmiyengal People," in *Living with Ghosts: Legacies of Colonialism and Fascism* (Gothenburg: L'Internationale Online, 2019).

15
Report from the Aboriginal Land Rights Commission, 1973, 5.

16
Ibid. See also Andrew Schaap, "The Absurd Logic of Aboriginal Sovereignty," in *Law and Agonistic Politics*, ed. Andrew Schaap (Farnham: Ashgate, 2009), 209–25.

17
Jeffrey Kahn, *Islands of Sovereignty: Haitian Migration and the Borders of Empire* (Chicago: University of Chicago Press, 2019).

18
Sigmund Freud, *The Future of an Illusion* (New York: W. W. Norton & Company, 1989), 21.

19
Sigmund Freud, *Civilization and Its Discontents* (New York: W. W. Norton & Company, 2005), 39.

20
Ibid., 41.

21
Ibid., 45.

22
Jacques Lacan, "The Mirror Stage as Formative of the Function of the *I* as Revealed in Psychoanalytic Experience," in *Écrits: The First Complete Edition in English*, trans. Bruce Fink (New York: W. W. Norton & Company, 2007), 75–81.

23
Luce Irigaray, "The Question of the Other," *Yale French Studies*, no. 87 (1995): 7–19.

Shapes of Freedom:
A Conversation with
Kim Turcot DiFruscia

Kim Turcot DiFruscia Liberalism's "work" on the body is at the heart of your thought. In your book *The Empire of Love* (2006), you make a conceptual distinction between "carnality" and "corporeality." How do you pose the sexual body through that distinction?

Elizabeth A. Povinelli *Empire of Love* makes a distinction between "carnality" and "corporeality" for a set of analytical reasons: to try to understand materiality in late liberal forms of power and to try to make the body matter in post-essentialist thought. If we think with Foucault then we understand that objects are object-effects, that authors are author-effects, that subjects are subject-effects, and that states are state-effects. And if we think after the critique of metaphysics of substance—say, with Judith Butler—then we no longer think that the quest is to find substances in their pre-discursive authenticity. Instead, we try to think about how substances are produced. I believe we are now accustomed to thinking like this. But something paradoxical happened on the way to learning about object-effects and learning how to critique the metaphysics of substance: the world became rather plastic and the different "modalities of materiality" were evacuated from our analysis. It left some of us with questions like: How can we grasp some of the qualities of a material object that is nevertheless a discursive object? How can we talk about subject-effects and object-effects without making materiality disappear or making its different manifestations irrelevant to the unequal organization of social life? How can we simultaneously recognize that discourse makes objects appear, that it does so under different material conditions, and that the matter that matters from discourse is not identical to discourse? Of course, this

is a slippery path; the peril is that we will fall back into metaphysics of substance.

"Corporeality" would be the way in which dominant forms of power shape and reshape materiality, how discourses produce categories and divisions between categories—human, nonhuman, person, nonperson, body, sex, and so forth—and "carnality" would be the material manifestations of that discourse which are neither discursive nor pre-discursive. When we talk about sexuality, but also about race and the body, I think this analytic distinction matters. In *The Empire of Love*, I first try to show how it matters and second how difficult it is to speak about those material matters without falling back into a metaphysics of substance. For instance, in the first chapter, "Rotten Worlds," I track how a sore on my body is discursively produced, and how the multiple discursive productions of this sore are simultaneously a production of socialities and social obligations. Sores are endemic in the Indigenous communities in which I have been working for the last twenty-five years or so in northern Australia. If I put my trust in the people whom I have known better than almost anybody else in my life, I would say that my sore came from contact with a particular Dreaming, from a particular ancestral site—which is actually not ancestral because it is alive. But this belief—or stating this belief as a truth—isn't supported by the world as it is currently organized; or, it is supported only if they and I agree that this truth is "merely" a cultural belief. But if the sore is thought of as staphylococcus or as anthrax or as the effect of the filthiness of Aboriginal communities, as it has been by physicians in Montreal or Chicago or by Darwin, then this thought meets a world which treats it as truth, as fact. These ways of examining the sore would fall under the concept

of corporeality: How are the body and its illnesses being shaped by multiple, often incommensurate discourses? How are these discourses of inclusion and exclusion always already shaping and differentiating bodies, socialities, and social obligations—mine and those of my Indigenous colleagues?

And yet the concept of corporeality is not sufficient. Whether the sore is an eruption of a Dreaming or the effect of poor health care and housing and structures of racism, it still sickens the body—and depending how one's body has been cared for, or is being cared for, it sickens it in different ways and to different degrees. Over time, sores such as the one I had on my shoulder, as discussed in *Empire of Love*, often lead to heart valve problems, respiratory problems, and other health problems for my Indigenous friends. In other words, no matter what the sore is from a discursive point of view, no matter what causes it to appear as "thing," the sore also slowly sickens a body—a material corrodes a form of life. And this slow corrosion of life is part of the reason why, if you are Indigenous in Australia, your life runs out much sooner than non-Indigenous Australians. And if the state provides you rights based on longevity—think here of the stereotype of the old traditional person—but you are dying on average ten to twenty years sooner than non-Indigenous people, then the carnal condition of your body is out of sync with the apparatus of cultural recognition. But this body-out-of-sync is a more complex matter than merely the discourse that has produced it, nor is it going merely where discourse directs it. Carnality therefore becomes vital to understanding the dynamics of power. I would say that Brian Massumi and Rosi Braidotti are engaged in similar projects.[1] But my theoretical, conceptual interlocutors are a more motley crew: American pragmatism,

Chicago metapragmatics, Foucault, Deleuze, late Wittgenstein, Heidegger and his concept of precognitive interpretation, what Bourdieu borrowed and turned into *doxa*. All of these folks are in a conversation in two important ways: first, they assume the immanent nature of social life, and second, they are interested in the organization and disorganization, the channeling and blockage, of immanent social life. I take for granted that an *otherwise* exists everywhere in the world, but my question is: What are the institutions that make certain forms of *otherwise* invisible and impractical? And one answer takes me to the corporeal and the other to the carnal.

 When I think about sexuality and race I think about them through this dual materiality. I think about sexuality and race primarily as corporeal regimes. And when I think of them as corporeal regimes, then the question for me is, what are the discourses that shape and reshape the flesh and its affects? This is where the civilizational division between the autological subject and the genealogical subject comes into the picture. Your body and mind might be female, but this discursive fold is apprehended differently than my female friends in Australia, because striated through gender, sexual, and racial difference is another discursive division of late liberalism: the divide between the autological subject and the genealogical subject.

> **KTD** To say that the autological/genealogical divide is the configuration of institutional power prior to the sexual divide seems confrontational to feminism …

EP Certainly in *The Empire of Love*, but also across my writings, I have kind of stubbornly refused to say how my work relates to feminism. In fact, *Empire of*

Love begins in a somewhat confrontational way, not exactly with feminism, but with sexuality, sexual theory, and queer theory. I say that I am not interested in sexuality or the woman question or for that matter the race question in the abstract. I am interested in them only insofar as they are what organizes, disorganizes, and distributes power and difference. Of course, I think this makes me a feminist—and certainly a queer! But when I think about what organizes, disorganizes, and distributes power and difference, I am led to a set of more intractable issues below a certain field of visibility as defined by identity categories. And these issues cut across liberal forms of intimacies, the market, and politics. These concrete formations of liberal power took me to the division of the autological subject and genealogical society rather than to the sexual division.

KTD Is it because you feel that the sex/gender question is a liberal question?

EP What I find to be a liberal question is not the sex/gender question but the organization of "identity" (whether sex, sexuality, gender, or race) on the basis of a fantasy of self-authorizing freedom. By self-authorizing freedom I mean the bootstrap relationship between the "I" of enunciation and the "I" enunciating—what do *I* think, what do *I* desire, I am what *I* am, I am what *I* want. And the trouble with this form of bootstrap performativity is not merely that it is a phantasmagorical figure of liberalism but that it continually projects its opposite into the worlds of others. What is projected is the equally phantasmagorical figure of the genealogical society—society as a thing that threatens to control and determine my relation to myself. Thus "freedom" and its "threat" are co-constituted. The freedom of the

autological subject, on which demands for same-sex marriage or self-elaborated gender identity are based, is always pivoted against fantasies of communities lacking this performative form of freedom. And just to be clear, I do not believe that there are actually genealogical societies and autological societies. Instead, there is a demand that one give an account of what she is doing in terms of this discursive division. In other words, the division of the autological subject and genealogical society is not about differences in the world. It is about a differential spacing of the world. Thus, sex/gender, sexuality, and other forms of difference aren't liberal per se. They become liberal when they are organized through this late liberal division and become legitimate vis-à-vis this division.

KTD Why did you choose love and intimacy as the place from which to discern these liberal processes of legitimation?

EP When liberals experience themselves as facing an instance of a so-called morally repugnant form of life, they insist that not all forms of life should be allowed to exist—or to be given the dignity of public reason. Too much difference is said to lie outside reasonable disagreement. The political theorist Michael Walzer's work is exemplary of these approaches, for instance.[2] This is an irresolvable limit internal to liberalism's account of itself. In *Cunning*, I was interested in how recognition projects this internal liberal tension between public reason and moral sense onto the subject of recognition and says to her, "You figure out how to be different enough so we can feel you are not me, but not so different that I am forced to annihilate you and thereby fracture the foundation of my exceptionalism."

In *Empire* I became more interested in the discursive content of the liberal governance of difference rather than merely its interactional dynamic, and in the dispersed sites of liberal governance. This is why I ask: How do we practice our deep, thick everyday lives so that we continually perpetuate the way that liberalism governs difference, even when we seem to be doing nothing more than kissing our lover goodbye? Every time we kiss our lover goodbye within liberal worlds, we project into the world the difference between the autological subject (the recursive ideology of the subject of freedom, the subject that chooses her life) and the genealogical society (the supra-individual agency threatening to condition our choice). The intimate event is an anchor point because it seems to me to be the densest, smallest knot where the irrevocable unity of this division is expressed. What do I mean by an irrevocable unity? In the intimate event the subject says two things simultaneously. On the one hand, the subject says, "This is my love, nobody can choose it for me, I am the author of my intimacy." Love is thereby treated as uniquely and unequivocally autological.

Forget Marx—the only thing that we have that is really ours is love! But at the same time, the subject also thinks, feels, evaluates love in terms of its radical, unchosen quality: "Love *happens*, I *fall* in love, I hope it happens to me," like I were struck by lightning. And the intimate event is an unavoidable anchor point. Even those people who might say that they will not love, that they hate love, that they do not want to love, have to have a relationship to love.

> **KTD** We understand that liberalism needs love to be projected in social forms of constraint such as marriage, but why is this particular metaphysical, almost magical ideology of love needed?

EP In love, the subject paradoxically realizes that she is never only autological; that "something" like a lightning strike has to happen to her which is out of her control, whether this event comes from the outside or from an inside so internal that it might as well be outside. Love is where the autological subject expresses herself most profoundly and where genealogical constraint expresses itself more purely. It is right there that you can see the liberal division that organizes social life collapse into itself and then explode outward. Paradoxically, it is in the moment the divide collapses in the intimate event that the differences between civilizational orders seem clearest to liberal subjects. The moment the liberal subject of love, the liberal subject *in* love, experiences her inability to author the event of love, she insists there is a vast and insurmountable difference between societies of freedom and societies of social constraint. One is tempted to become a psychoanalyst to explain this. And no wonder it seems metaphysical. But it comes from within and sets up specific social orders.

KTD Social orders such as the ones set up by identity politics?

EP Yes. One of the reasons why I wanted to write *The Cunning of Recognition* (2002) was to start to push back against the seductions of identity. I started graduate school in the eighties with a background in philosophy. A while after, I went to Australia on a fellowship and the Indigenous friends I made there needed an anthropologist. Under the Land Rights Act, a piece of legislation that allowed Indigenous Australians to sue for the return of their land, Indigenous groups had to be represented by an anthropologist and a lawyer. I had no intention of

becoming a lawyer! So I left aside my "great" books and entered graduate school at Yale in anthropology. This was in 1986, at exactly the moment when the field, like many other disciplines, was reflecting on its enmeshment in worlds of power, including colonialism and imperialism. And then the book *Writing Culture* came out. So huge fights were breaking out, with people accusing other people of racism, colonialism, homophobia, objectivism, scientism. One response to these charges was the collapse of the object of study into the identity of the studier. Many tremendous studies have come out of this maneuver. But what was lost was how the critique of power might impact at a deeper, richer level with immanent forms of social obligation beyond given articulations of identity. The threat was that everyone became merely what identity-form existed, and in the most deracinated of ways. No one is merely the given form of identity. Every identity is shot through with unnamable networks of deep unspecifiable, unnamable obligation. And these nonreferential forms of obligation were abandoned. The task isn't to think about oneself or one's personal history, but instead to remain in the obligations that we find ourselves responding to, while at the same time understanding the arts of governance that disrupt and contain and redirect these immanent modes of obligation.

KTD In your last book, *Economies of Abandonment: Social Belonging and Endurance in Late Liberalism* (2011), as well as in *The Empire of Love*, you specify that you are interested in late liberal formations of power. Can you explain the relationship of late liberalism to neoliberal modes of governance? How is the distinction useful politically?

EP I have gone back and forth between reserving the phrase "late liberalism" for the liberal governance of difference that began to emerge in the late 1960s and early 1970s as liberal governments responded to a series of legitimacy crises coming from anti-colonial, anti-imperial, and new social movements, and using the same phrase to refer to the internal and external conditions and dynamics of contemporary European and Anglo-American governance as two of its key pillars, neoliberalism and multiculturalism, emerged in the 1970s and are now undergoing significant stress. My vacillation is symptomatic of the absolute need to distinguish these two modes of governance, to never let either out of the sight of the other. From a political point of view of collective and legitimate action, the neoliberal governance of economies and the multicultural governance of difference were always about the conservation of a specific form of social organization and distribution of life and goods. How can this be when these two forms were new twists in liberal capitalism? How could they be conserving older forms of social organization and be a new form of social organization at the same time?

What interests me is the conservation of differential powers as capitalism was understood as liberation from the market and liberal values were liberated from liberalism. How are these changes conditioned by events inside and outside Europe and the Anglo-American region? How are the consequences of these changes reflected in the forms and affects of liberal governance? What forms of liberal economic and social governance are emerging as the center of economic vitality shifts from the US and Europe to Asia and South America? What is liberalism becoming as nondemocratic forms of capitalism are a central engine of the global economy;

nonelected "technocratic" governments are proliferating in Europe; social protest and massive youth unemployment are ubiquitous; secular and religious imaginaries compete on the street; and slums proliferate as the major form of social dwelling in the South and suburbs become ghettos in the North?

KTD You wrote about Genet's *Querelle de Brest* in "Notes on Gridlock: Genealogy, Intimacy, Sexuality."[3] If we cut ourselves from thoughts on identity, recognition, or deliberative democracy, how can an experiment in the ethics of radical loneliness similar to Querelle's still maintain roots or connections in these obligations?

EP Lee Edelman and Leo Bersani, who has written so provocatively about Genet, think the queer against the common, the communitarian.[4] The queer for them refers to the practices or events of radical social, psychic, and epistemological disruption. They understand the queer to be located in (or to be) the unclosable gaps that open in discourse, psyche, and epistemology—say, between rhetoric and grammar. In these spaces, all forms of normality are shattered and no new hegemonic forms have yet emerged. So, queering would be the shattering of a given sociality, identity, or community without the desire or promise of a new sociality, identity, or community. In Bersani's way of putting it, queer moments are moments in which the self is liquified.

Honestly, I personally find these spaces, these moments, exhilarating. But I worry that a blanket valorization of these moments of liquification, shattering, and dissolving dangerously undertheorizes the unity of such shattering. What are the consequences of this kind of shattering if you are Indigenous in Australia, when your life is already

shattered, is shattering all of the time, and not because you are Querelle perusing the docks but because the liberal structures, said to recognize your worth, are instead constantly shattering your life-world? Thus, I think queer theory needs to do two things. First, yes, it needs to define queer on the basis of the shattering of subjectivity and the sheering of normativity, but also, second, it needs to demonstrate how this shattering is not itself a unified phenomenon. Indigenous friends of mine might live in zones of liquification, but their "queerness" is of a very different sort than my queerness. My liquifications might well help enhance my life, whereas theirs might not.

KTD So do you wish to add a little incommunicability?

EP And stir? Well. I wish to understand the goods and harms of *in*communicability itself and to understand how these goods and harms are always already socially distributed. So, some groups seek to be incommunicable—or incommensurate—while others are structurally located within the incommensurate spaces of late liberalism. Their *logos* are made noise, made incommunicable, even if they are trying to communicate. And you see how different this is from Querelle's queer cultivating of an incommunicable self. And if queer theory doesn't acknowledge this difference, it flattens the social field. I love Genet's *Querelle*, but one must understand that the benefits and harms of living a shattered life are socially distributed. Again, this is why I am interested in both corporeality and carnality. One can celebrate Querelle's life on the docks. One can celebrate the docks in New York in the seventies. One can celebrate the various *otherwises* that emerge in

Indigenous communities. But what is it to live these various forms of life from a carnal point of view? What are the outcomes for bodies and assemblages of bodies?

KTD In "What's Love Got to Do with It?," you wrote about how "violence against women" is used as an excuse for genealogizing Indigenous communities.[5] Can you explain how you understand this resort to violence and sexual violence in liberal arguments?

EP Let me answer that question by first providing a certain intellectual history to how I think about violence. At the University of Chicago there was a group called the Late Liberalism Group. The members were Michael Warner, Saba Mahmood, Lauren Berlant, Candace Vogler, Elaine Hadley, Michel-Rolph Trouillot, Patchen Markell, and myself. One of the things we were puzzling about was how to think about violence diagonally to liberal accounts of violence. How do we refuse the way liberalism divides violence and nonviolence? How do we penetrate violence, acknowledge it outside of definitions of violence engendered by liberal arts of governance? That was the framework within which I began to think about violence, which is such a sticky matter. Violence is not—any more than the queer—an ontological category that we can define and then correlate to objects in the world according to how well they fit the definition. Violence is organized by liberal discourses, such as the autological/genealogical divide. And one of the ways I try to angle into violence is by moving away from violence and thinking about care, and how forms of what constitutes care have shifted in late liberalism. For one thing, there is a shift in the location of care—from

the Keynesian state, which provided a minimal level of care, a minimal level of vitality, to those most in need, to the current neoliberal state, which removes this cellar of care and shifts the responsibilities of care from the state to the individual. Foucault began teasing out this shift in *Naissance de la biopolitique* (1979). He argued that neoliberalism is not laissez-faire anymore. It is not about leaving the market alone. It is about aggressively expanding the logic of the market to all aspects of life so that market principles actually become human principles that organize life, government, intimacy, and so forth. Thus, in neoliberalism, "caring for others" involves removing the social resources of care and inserting market evaluations and values. The arts of governance use the same word across the shift—"care"—but the social organization of care has changed dramatically.

This shift makes certain statements impractical and infelicitous. Certain statements do not have practical traction in the world. Why don't we think that removing social welfare is a form of state killing? Especially when the neoliberal state says that its way of "caring" will make life unviable for many. "Life is going to get much worse," we are told, "but just wait and then things will get better." Why do we think of this as care and not as state abuse? How long are we willing to give late liberal forms of care-as-enervation before we are willing to call them a form of killing? But even if we did name this form of care as a form of abuse, our statement could not do anything practical in the world if all the social fields of that world—intimacy, market, child rearing, and so forth—are organized around the same late liberal model of care.

When it comes to the difference between, say, feminists who oppose violence against women, and Querelle, who craves violence as a form of

de-subjectification, we must be extremely careful to differentiate the social grounds of these desires. Take, for example, how violence against women was used as a justification for attacking Afghanistan. One reason it was difficult to mobilize a counter-discourse was that opposing the government's protection of women was treated as if it were support for violence against women, as if these were two sides of the same coin. Of course, violence against women is not acceptable. But if we turn away from the problem of violence and look at the social grounds and purpose of violence, we see something quite different. Take another example. We are currently witnessing a radical federal intervention in Indigenous governance in Australia. A government report noted the horrific conditions of life in Indigenous communities in the Northern Territory. The report stated that *in the worst cases* these horrific conditions have led to child sexual abuse. More or less than anywhere else? Nobody knows. And the report didn't say. Nor did it quantify its claim about child sex abuse. But the conservative federal government stoked a sex panic to legitimate a late liberal reorganization of social welfare and a seizure of Indigenous lands. It sent troops into Indigenous communities to take control of community affairs. It is hard to explain how in such a short interview, but the federal government and its policy supporters were able to convince the public that the cause of this sexual abuse was traditional Indigenous culture. As a result, the government was extremely successful in disrupting hegemonic alliances on the Left, because the only question that could be asked or answered became: Are you for or against Indigenous child sex abuse? Of course, it is not about that, but there was no escape. No matter what you say and no matter

how you say it, you are read in relation to the sex panic. When you say it is a sex panic used to justify a governmental intervention, people answer, "So you are for sexual abuse of children!" Exactly like violence against women and the invasion of Iraq and Afghanistan. So these are the kinds of liberal and neoliberal imaginaries of violence and care against which we need to think.

KTD Violence and sex!

EP Yes. So the question for me is, like sex, how do you tackle the problematic of violence without already acceding to the terms that liberalism sets for what is violent and what is nonviolent, even as liberalism itself shifts forms—classical laissez-faire liberalism to Keynesian liberalism to neoliberalism?

KTD Clearly the agency/constraint, individual/society question is not a pertinent question for anthropology to ask. What is a good question, according to you?

EP If we take the example of this federal intervention in Australia, we see clearly how shifts occur in the definitions of both the agency/constraint and individual/society division. Liberal recognition first stated that it cared for Indigenous people by enclosing them in culture. But the form of "culture" liberalism recognized was genealogical. Members of Aboriginal communities were cared for through culture, but this was culture as determination and as opposed to subjects of freedom. The recent federal intervention has conserved this division, even as it has inverted the value of genealogy. The federal intervention maintained the distinction between the

people of freedom and the people of cultural determination. But now Indigenous culture is the cause of Indigenous pathology rather than the cure for it. So a good question for me would be one that opened a new line of thinking, such as, how might we rethink the spaces of the *otherwise* in terms of obligation and care, or exhaustion and persistence?

Kim Turcot DiFruscia is a PhD candidate and lecturer in the Department of Anthropology at the Université de Montréal. Her research interests include the political experience of management, the history of corporate subjectivation, human resource management, and psychological govermentality under late liberalism.

1
See, among others, Brian Massumi, "Introduction: Concrete Is as Concrete Doesn't," in *Parables for the Virtual: Movement, Affect, Sensation* (Durham, NC: Duke University Press, 2002), 1–22; and Rosi Braidotti, *Metamorphoses: Towards a Materialist Theory of Becoming* (Cambridge: Polity Press, 2002).

2
See, among others, Michael Walzer, *Politics and Passion: Toward a More Egalitarian Liberalism* (New Haven, CT: Yale University Press, 2004).

3
Public Culture 14, no. 1 (2002): 215–38.

4
See Lee Edelman, *Homographesis: Essays in Gay Literary and Cultural Theory* (New York: Routledge, 1994); and Leo Bersani, *Homos* (Cambridge, MA: Harvard University Press, 1996).

5
Social Analysis 49, no. 2 (Summer 2005): 173–81.

The Virus: Figure and Infrastructure

i.

Not what is critique. Not what is a concept or a book. But perhaps, why this critique, this concept, this book? Why *Geontologies* and its obsessions with Life and Nonlife, with its figures of geontopower, with its hovering in the space between Gaia and ground after economies of abandonment, empire of love, cunning of recognition? The most straightforward answer is that every one of my books emerges from a limit condition in the previous one, as this limit condition encounters new discursive material currents and arrangements of the present. In this present, a world engulfed by a virus violently severed from its customary relation with the nonhuman world and, as it seeks its new settings, killing and maiming those people who already bare the embodied imprint of racist and colonial histories, what is the afterlife, the limit of the concept of geontopower and one of its figures, the Virus?

Concepts and their figures are born genealogically, of unexpected alignments of entangled regions of interests. Geontology was first introduced as a concept in 2012 at the Australian National University as part of the Annual Meeting of the Consortium of Humanities Centres and Institutes' "Anthropocene Humanities" symposium. The invitation to participate was my initiation into the concept of the Anthropocene. My previous book, *Economies of Abandonment*, had dove deeply into the critical literature on biopower—Arendt and her Greeks; Foucault and his figures; Agamben and two modes of potentiality; Mbembe and the spectacles of postcolonial necropower; Esposito and his positive and negative biopolitics—in order to focus on a certain moment, or condition, in the life of alternative social projects; those moments, or those conditions in which a social project is neither something, nor

nothing, but rather violent oscillation in the torrents of late liberal power. When I was invited to present a talk at the Anthropocene symposium, I was struggling, in the wake of *Economies of Abandonment,* to articulate a space of governance that didn't preclude, even as it subsumed, biopolitics. How could one celebrate an otherwise that is located within landscapes where "wavering of death" defines a space that does not wonder about the practices of endurance within it, let alone the dynamics therein by which such otherwise might thicken to a something, find itself as such, and then deepen and extend before the weight of late liberal governance discovers and crushes it?

This critical focus on what felt at the time to be a callous celebration of the pure potential within zones that shutter rapidly and violently, or ever so slowly, between life and death, prompted me to reflect on my early work, on what started all these books; namely, the request by the Indigenous women I first met at Belyuen, Northern Territory, in 1984, for whom I credentialed myself as an anthropologist so we could jointly analyze a *berragut* (white person, settler) mode of governance. This mode of liberalism, what I would come to call late settler liberalism, went by the name of "Aboriginal self-determination." The senior women primarily encountered this mode of governance via the Northern Territory Land Rights Act of 1976. This act claimed to recognize and embrace Indigenous difference, but in fact and practice demanded that Indigenous people shape themselves into forms conducive to settler colonialism—to be different enough that settler colonialism could tell itself it was recognizing difference, but not so different as to threaten communicative or moral reason of the settler state. In *The Cunning of Recognition*, I argued that the statement that

animated state-sanctioned Aboriginal self-determination had "become a form of difference for us that makes no difference to us." And the form of difference settler colonialism enjoyed most were stories by Indigenous people who were forced to tell about their relationships with not only the more-than-human animal world, but more compellingly, their mineral and meteorological existence.[1] What was the reason settler law and publics could enjoy this difference? Because Indigenous analytics of the deep interdependencies and formations of existence did not seem to touch the epistemologies and ontologies governing settler reason. Settler reason was safely entombed in its schizoid divisions of Life and Nonlife, providing them entrée into jouissance—the experience of transgressing their own geontological limit without threat to the benefits of geontopower. By the time of *Economies of Abandonment*, I was more interested in how an otherwise endured these conditions, suggesting two strategies that had a companion relation to late liberal recognition—espionage and camouflage—that I now see as mode of the figure of the Virus.

It was out of these diverse conditions that *Geontologies* attempted, on the one hand, to assault a critical blindness within the scholarship on biopower, namely geontopower, and on the other hand, to find a critical language to account for the moment in which a form of power long operating in the open in settler late liberalism was now becoming visible globally under the name of Anthropocene and Climate Change. The book's intention was not to found a new ontology of objects, nor to establish a new metaphysics of power, nor to adjudicate the possibility or impossibility of the human ability to know the truth of the world of things. Nor was geontopower offered as a new formation of power

replacing biopolitics. Instead it sought, in the spirit perhaps of Mbembe's approach to necropolitics, to demonstrate how geontopower has long been foundational to critical thought, the governance of difference, and the extractive machinery of capitalism and its markets. The attribution to various colonized people of an inability to differentiate the kinds of things that have agency, subjectivity, and intentionality of the sort that emerges with life has been the grounds of casting them into a premodern mentality and a post-recognition difference. In short, *Geontologies* meant to provide a fuller account of the shape of a set of critical discourses and figural images coming into view as the presuppositional nature of *geontopower* cracked; and to orient a different way of consolidating discourses.

With these intentions in mind, *Geontologies* introduced a set of figures that I claimed had always accompanied, but now were assuming a greater discursive space from, the four figures of biopower. The four figures of sexuality emerged, as Foucault noted, from "four great strategic unities which, beginning in the eighteenth century, formed specific mechanisms of knowledge and power centering on sex."[2] These strategic unities (a hysterization of women's bodies; a pedagogization of children's sex; a socialization of procreative behavior; and a psychiatrization of perverse pleasure) were the effects of a host of other permutations of power as Christiandom refigured the Greek uses of pleasure and a new science of life refigured confessionary sexuality. And why did this refiguration occur? The "myriad of clashing forces" in successive forms of government from the Middle Ages to the eighteenth century refigured previous "great forms of power" that had "functioned as a principle of right that transcended all

the heterogeneous claims."[3] The clash of forces, then, was not the clash of armies but currents that crossed the mobile relations of power, that operated and slipped among the equilibriums and disequilibriums of any arrangement, and that gave rise to new forms and arrangements that were necessary only retrospectively. These forces figured the four figures of sexuality—the hysterical woman, the masturbating child, the Malthusian couple, and the perverse adult. These are the figures biopower diagrammed and made available for liberal concern. But lurking among them were other arrangements, forms, and figures; ghostly specters liberalism glimpsed at the corner of its eyes, appearing as if feverous symptoms of some aspect of themselves they could not put their fingers on. Let me be clear: although *Geontologies* named three figures that geontopower makes us speak of, manage, fear, assault, and embrace—namely, the Desert, the Animist, and the Virus—the diverse terrain of late settler liberalism is populated by hosts of other actual and immanent others.

Rather than exits from geontopower, the Desert, the Animist, and the Virus were meant to be diagnostic and symptomatic of the ways in which those who have benefitted from geontopower are responding to its potential incapacitation. They weren't meant to refer to deserts, animists, or viruses in themselves, in the sense of forms of existence subject to geontopower, but rather to geontopower's reassertion of its governance over existence. It is because of this that I chose the figure of the Virus rather than that of the Terrorist, even as the Terrorist is within the broad imaginary of the Virus. Even when thinking of the Virus as a *figure* of geontopower's loss of self-evident legitimacy, I tried to forestall the celebration of it as a radical exit from

geontopower. I noted, "While the Virus may seem to be the radical exit from geontopower at first glance, to be the Virus is to be subject to intense abjection and attacks, and to live in the vicinity of the Virus is to dwell in an existential crisis." And I noted that capitalism is the epitome of the Virus as well as the major producer of it.

ii.

Covid-19 has made these cautions terrifyingly clear. The rhetorics of war, the replacement of the discourses of citizenship with those of civilians, the reemergence of a militant white supremacy in the US and Europe, and the hardening of nationalisms have attempted to block those demonstrating how colonizing capitalism is the Virus, facilitated the virus's spread, and accounts for its differential impact on Indigenous, Black, and brown people. The actual virus, then, becomes a figure of geontology's failure to govern in such a way that the values of capital extraction flow primarily into the white North while the toxicities that are produced along the way remain within the primarily brown and Black Global South. In other words, the relays between the figure of the Virus and the actual SARS-CoV-2 virus become increasingly rapid and ever more important to disentangle.

Rhetoric and practices of war have accumulated around Covid-19. In New York, during the rise of the crisis, Governor Andrew Cuomo strained to come up with new metaphors of war, battle, and combat. "This is a war, we have to treat it as a war." Cuomo was hardly alone in his imaginary stance. Costanza Musu provided an international overview of the rhetorics of war that enveloped national responses to the circulation of the virus, from Queen Elizabeth II's evocation of the Second World War ("we will meet

again") to UN Secretary-General Antonio Gutiérrez's claim that "this war needs a war-time plan to fight it."[4] Strongmen, from Viktor Orbán in Hungary and Rodrigo Duterte in the Philippines to Xi Jinping in China, sought to mobilize internal campaigns of political repression under the guise of fighting the heroic battle against Covid-19. These rhetorics of war are also a feature of the figure of the Virus. In *Geontologies*, I noted that if the central imaginary of the Desert was the *carbon imaginary* (the scarred homology between biological concepts such as metabolism and its key events of birth, growth-reproduction, and death, and philosophical concepts such as event, conatus/affectus, and finitude), and the central imaginary of the Animist is the *Indigenous society* in perfect balance with Nature, the central imaginary of the Virus is the *terrorist*. The *terrorist*, like the *carbon imaginary*, and the *Indigenous society* are spectral projections of geontopower. They are both disavowals of their internal relationship to geontopower and abjections onto those who have suffered from geontopower. The terrorist is a projection onto anti-colonial and anti-capitalist movements and a disavowal of the terror of the history of colonial capitalism present in the global form of late settler liberalism. In this discourse of disavowal, the Virus-as-terrorist lurks among us, unseen, camouflaged, taking advantage of the freedoms afforded by late liberal capitalism. Its viciousness is in equal proportions to its invisibility. It is the inverse of everything late liberal capitalism stands for.

But Covid-19 is neither a friend nor an enemy of late liberal capitalism or those who seek to live its refusal. It neither seeks to kill nor extend its dominion. Instead, radically agnostic to its form, Covid-19 is the result of capitalism's continuing colonization

of the entirety of existence and extends through the infrastructures of late liberal markets and their defenses. We know this. We also know that Covid-19 is only "a virus," the SARS-CoV-2 virus, in an abstract sense. Its recent ancestor was once the internal node of a previous entanglement with bats and their environs, and Covid-19 is the residual of the capital colonization of that arrangement.[5] We cannot know what its future form in whatever new entanglement it expresses itself will be. What we do know is that its present operation—its new form of dwelling—is diagnosing the structures and contours of power of the ancestral presence of geontopower.

To see how the actual virus is diagnostic and symptomatic of geontopower, we need to understand how the figure of the Virus-as-Terrorist blocks this analytic. This is, after all, what the figures of biopolitics and geontopower do. They huddle just inside the door between the given arrangement of geontological governance and its otherwises, trying to block entrances and exits to anyone and anything that attempts to reshape its interiors and exteriors. Figures may be symptomatic of the crumbling of geontopower but they are still diagrams of it. Instead of approaching the current pandemic within this geontological imaginary, we need to see it as yet another form of toxicity that colonialism has seeded. Toxicity technically refers to those substances that are biologically noxious or poisonous—those things that have the capacity to disrupt biological function. But the relationship between toxic and nontoxic things is not a line so much as a matter of degree. All substances have within them the capacity to become toxic; all substances can move from medicine to poison, hero to scapegoat.[6] Even the purest of waters can be toxic to humans if taken in sufficiently large doses. Thus, medical discussions of toxicity typically

emphasize the means by which toxins enter the body and the amount a body can process safely before becoming overwhelmed. Climatic overheating, while technically external to the body, can disrupt internal biological functions as profoundly as any chemical toxin. High temperatures don't literally boil the blood, but they put cardiac functions under serious stress even in the healthiest individual as they raise the level of ozone and other pollutants (pollen and other aeroallergens) which can dramatically affect preexisting cardiovascular and respiratory diseases. In this way, the heat index of rising temperatures and humidity are a part of a more general expansion of uninhabitable zones. What surprise then that the advice of certain policy experts for mitigating the effects of climate change sounds eerily like older advice for interacting with chemical toxins: don't let them in (seal yourself off with air-conditioning and air purifiers) or remove yourself from the contaminated area (join the great climate migration). The eerie similarities to the mitigation and containment strategies of the global Covid-19 pandemic are hard to miss. As Andrea Bagnato notes, with "the establishment of new networks of free circulation" and "permanent urban spaces" also came "unwelcome matter like viruses and bacteria," revealing "the misguided nature of Western aspirations to bring order and civilization to the rest of the world."[7]

We might also see viruses and their differential effects as traces of capitalism's extractive exhaustion of any form of existence it encounters. In this sense toxicity refers not merely to the overwhelming and exhausting of the body's immune defenses—the now well-known cytokine storm, causing more damage than the virus itself—but the exhaustion of the human and more-than-human world. An exhaustion of the violent extraction of

labor as a life force from enslaved men and women in the Caribbean that powered the emergence of liberal capitalism, as well as the extraction of minerals from soils which, as Filipa César has noted, anti-colonial writer and revolutionary Amílcar Cabral understood as a fundamental aspect of Portuguese enrichment from its colonies.[8] Toxicity as a form of extractive exhaustion is a material sedimentation. Covid-19's devastation of poor, Indigenous, Black, and brown communities is a horrifying analytic of this historical toxic sedimentation. Certainly, Covid-19 is not our friend. But it is not our enemy either. Covid-19 is a manifestation of the ancestral catastrophes of colonialism and slavery. Covid-19 is a manifestation of the continual destruction and dispossession of existence by the massive extraction and recombination machine of late liberal capitalism. In other words, structural racism and colonialism and their devastating effects on the health of Black and Indigenous bodies and their environments existed long before Covid-19. The catastrophe of climate collapse, toxic exposure, and viral pandemics are not *à venir*—they are not on the horizon coming toward those staring at it. These are the ancestral catastrophes that began with the brutal dispossession of human and more-than-human worlds and a vicious extraction of human and more-than-human labor. These dispossessions and extractions birthed liberalism and capitalism, and alongside them, a massive machinery that disavowed their structural violence. The rhetoric of war, the figure of the Virus as a Terrorist, directs attention away from late liberal capitalism as the quintessential Virus, the quintessential Terrorizer, the source of this horror we are experiencing. We are told, instead, to view the virus within the framework of what, in *Empire of Love*, I called "ghoul health," namely, the

global organization of the biomedical establishment and its imaginary around the idea of the big scary bug, the new plague. Ghoul health is, in other words, the prefigure of the concept of the Virus. It is the bad faith of geontopower in which the real threat is not the virus but the contemporary global division, distribution, and circulation of health. It is the bad faith we are living unevenly.

1
Elizabeth A. Povinelli, "Do Rocks Listen? The Cultural Politics of Apprehending Australian Aboriginal Labor," *American Anthropologist* 97, no. 3 (September 1995): 505–18.

2
Michel Foucault, *Histoire de la sexualité 1: La volonté de savoir* (Paris: Éditions Gallimard, 1978), 103.

3
Ibid., 87.

4
Costanza Musu, "War Metaphors Used for COVID-19 Are Compelling but Also Dangerous," *The Conversation*, April 8, 2020, https://theconversation.com/war-metaphors-used-for-covid-19-are-compelling-but-also-dangerous-135406.

5
Maciej F. Boni et al., "Evolutionary Origins of the SARS-CoV-2 Sarbecovirus Lineage Responsible for the COVID-19 Pandemic," *Nature Microbiology* (2020), https://www.nature.com/articles/s41564-020-0771-4.

6
Jacques Derrida, "Plato's Pharmacy," in *Dissemination*, trans. Barbara Johnson (Chicago: University of Chicago Press, 1981).

7
Andrea Bagnato, "Microscopic Colonialism," *e-flux architecture*, December 13, 2017, https://www.e-flux.com/architecture/positions/153900/microscopic-colonialism/.

8
Filipa César, "Meteorisations: Reading Amílcar Cabral's Agronomy of Liberation," *Third Text* 32, nos. 2–3 (2018): 254–72.